In *Critical Condition,* Eleanor Heartney examines the art world from 1985 to 1994, a tumultuous period that ushered in the art boom and bust, the emergence (and in some cases disappearance) of developments like Appropriation, Neo-Geo, and multiculturalism, and the ongoing attack on art by the religious Right and political conservatives. Chronicling events that took place during this decade, with a particular focus on public art, Heartney also examines the mechanisms of the gallery and media system, especially as they relate to the practice of art criticism, as well as the complexities of the debate on art and pornography. Written during a pivotal period of contemporary art, Heartney's essays provide a picture of a culture in a crisis of values that has yet to be resolved.

Critical Condition

CONTEMPORARY ARTISTS AND THEIR CRITICS

GENERAL EDITOR

Donald Kuspit, *State University of New York, Stony Brook*

ADVISORY BOARD

Matthew Baigell, *Rutgers University*

Lynn Gamwell, *State University of New York, Binghamton*

Ann Gibson, *State University of New York, Stony Brook*

Richard Hertz, *Art Center College of Design, Pasadena*

Udo Kulturmann, *Washington University, St. Louis*

Judith Russi Kirshner, *University of Illinois, Chicago*

This series presents a broad range of writings on contemporary art by some of the most astute critics at work today. Combining the methods of art criticism and art history, their essays, published here in anthologized form, are at once scholarly and timely, analytic and evaluative, a record and critique of art events. Books in this series are on the cutting edge of thinking about contemporary art. Deliberately pluralistic, the series represents a wide variety of methodologies. Collectively, books published in this series will deal with the complexity of contemporary art from a wide perspective in terms of both point of view and writing.

Critical Condition

AMERICAN CULTURE
AT THE CROSSROADS

ELEANOR HEARTNEY

CAMBRIDGE
UNIVERSITY PRESS

PUBLISHED BY THE PRESS SYNDICATE OF THE UNIVERSITY OF CAMBRIDGE
The Pitt Building, Trumpington Street, Cambridge CB2 1RP

CAMBRIDGE UNIVERSITY PRESS
The Edinburgh Building, Cambridge CB2 2RU, United Kingdom
40 West 20th Street, New York, NY 1011–4211, USA
10 Stamford Road, Oakleigh, Melbourne 3166, Australia

First published 1997

Printed in the United States of America

Typeset in Bembo

Library of Congress Cataloging-in-Publication Data
Heartney, Eleanor, 1954–
Critical condition : American culture at the crossroads / Eleanor Heartney.
p. cm. – (Contemporary artists and their critics)
Includes index.
ISBN 0–521–55296–6 (hc). – ISBN 0–521–55763–1 (pb)
1. Art and society – United States – History – 20th century.
2. Multiculturalism – United States. 3. Postmodernism – United
States. I. Title. II. Series.
N72.S6H38 1996
701′.03′097309048 – dc20 96–15184
 CIP

A catalog record for this book is available from the British Library.

ISBN 0–521–55296–6 hardback
ISBN 0–521–55763–1 paperback

Contents

v

Illustrations

Essay Sources

"Appropriation and the Loss of Authenticity," *New Art Examiner*, March 1985.

"Neo Geo Storms New York," *New Art Examiner,* September 1986.

"Rehabilitating Abstraction," *New Art Examiner,* January 1988.

"Social Responsibility and Censorship," *Sculpture*, January 1990.

"Art in the 90s: A Mixed Prognosis," *New Art Examiner*, May 1990.

"Aesthetic Quality, Artistic Control," *New Art Examiner*, October 1993.

"High Priest or Media Flack? The Art Critic in the Age of Hype," *New Art Examiner*, April 1986.

"Artists vs. the Market," *Art in America*, July 1988.

"La critique d'art americaine dans le sillage des années 80," *art press,* October 1990, reprinted as "Art Impresarios: The Conjuring of the Critic-Curator," *New Art Examiner*, November 1990.

"David Salle: Impersonal Effects," *Art in America*, June 1988.

"A Necessary Transgression: Pornography and Postmodernism," *New Art Examiner*, November 1988.

"Pornography, Feminist Fundamentalism and the Transcendence of Self," originally published as "Pornography," *Art Journal*, Winter 1991.

"The Whole Earth Show," *Art in America,* July 1989.

"Against Nature/Primal Spirit," *Contemporania*, October 1990.

"The New Word Order," *New Art Examiner*, April 1991.

"Identity Politics at the Whitney," *Art in America*, May 1993.

"The New Social Sculpture," *Sculpture*, July-August 1989.

"What's Missing at Battery Park?" *Sculpture*, November 1989.

"Report from Newcastle: Cultivating an Engaged Public Art," *Art in America*, October 1990.

"The Dematerialization of Public Art," *Sculpture*, March-April 1993.

Critical Condition

Introduction

IN PRAISE OF UNCERTAINTY

Has American culture slipped into a critical condition? As I write this introduction in the fall of 1995, there is a growing sense, inside and outside the art world, that something is out of joint. This sense is fueled by a lackluster art market that refuses to be revived, an awareness that the institutions of the art world – the museum, the gallery, the art school, the alternative space – may not survive if they do not adapt to new economic and political pressures, and a perception that art itself is being lost in an endless cycle of repetition and revival. However, the most visible symbol of malaise may be the dismal progress of the debate over the fate of the National Endowment for the Arts. The virulence of the attacks on the NEA from the political Right is strikingly out of proportion to the effect the elimination of its minuscule budget would have on the national debt. Despite this fact, the art world has been unable to mount any effective response. Instead of making a spirited defense of culture, it has tended to focus on the NEA's low "failure rate," as measured by the small overall number of controversial grants and on vague evocations of art's capacity for uplift.

The elimination or preservation of the NEA will ultimately

be little more than a footnote in the history of culture in our era. Far more important is what the debate itself signifies. Recent political realignments seem to suggest that the American public has judged culture to be expendable. In the degraded populism of the day, it is seen as elitist, a drain on hard-earned tax dollars, and a haven for privileged, ivory tower liberals whose values run counter to those of the bedrock, "real" Americans. In the more extreme flights of rhetorical fancy, high culture has even been styled the "enemy of the people."

Within the institutional art world, the response to this state of affairs has been to call for more education. But in fact, the partisans of this view are anything but uneducated philistines. I think, for instance, of the used-book seller in northern New Hampshire who described himself as a "Rush Limbaugh conservative" and observed, "As far as I'm concerned, you can bury the NEA at the bottom of the sea." In another conversation recently, a young Russian-born Israeli immigrant working in the computer field countered my impassioned defense of culture with the remark that his idea of culture involved not artists, writers, and ideas but a kind of civility – cleanliness, social order, freedom to walk the streets unafraid of crime – that he saw sorely missing from American cities today.

Their solutions were surprisingly similar. The bookseller wanted to return all decisions about culture to the localities, and the computer specialist described his ideal society as one in which each group, and each economic and social function, from work, to entertainment, to consumption, to culture, was confined to its separate and inviolable sphere.

On reflection, I realized that what was wrong with both of these visions was that they run counter to the way culture actually develops in the modern world. Culture grows in places

where there is a certain amount of social chaos, where people of different backgrounds, different interests, and different desires are thrown together. Culture expands when creative people encounter heterogeneity, are forced to accommodate other views, and are stimulated by other aesthetics. Modern culture, in other words, requires the conditions most commonly found in cities. Yet, the current emphasis on localism, populism, and community standards is precisely an attack on the cosmopolitan idea.

It seems to me that we Americans have reached one of those turning points in our vision of what we might become. In a time of incredible flux and change – when geopolitical spheres of influence are being radically redefined, when a global economy is taking crucial economic decisions out of our hands, and when the look of the population and the customs that we call "American" are changing drastically – one overwhelming response has been to hold the chaos at bay. The current furor over values, whether it manifests itself in debates over school prayer, abortion, or the death penalty, reflects a desire for some kind of stability and certainty in a highly unstable world. And in this context, culture, at least the kind that was once associated with the term "avant garde," is seen as a destabilizing force.

Although a great deal of silliness often surrounds the defense of high culture in America, it is a fact that at its best, art helps us recognize the complexities of the world in which we live. At its best, art challenges us to reexamine our assumptions and to make contact with provocative individual visions that may be very different from our own. Thus, at a time when the yearning for simplicity and lost innocence is reaching its apogee, we should not be surprised that reminders to the contrary are increasingly unwelcome.

3

With the benefit of hindsight, I can see that the search for complexity is a recurring theme in this collection of essays, which were written for a variety of publications between 1985 and 1993. As an undergraduate studying philosophy at the University of Chicago, I wrote a bachelor's thesis entitled "The Certainty of Uncertainty." In perusing the following essays for the "deep structures" of my thought, I discern a continuing sympathy with this principle.

I chose the career of art criticism because it allows me to indulge my joint interests in art and cultural politics. I continue to be less interested in championing some particular movement or group of artists than in investigating the ways in which contemporary art sheds light on the tremendous changes that are shaking the modern world. Although it responds to its own history and internal logic, art is also finely tuned to larger social, political and economic forces. As a result, it becomes a wonderful milieu from which to observe the consequences of emerging ideas and shifts in the cultural landscape.

As a critic, I have come to believe that the most important thing I can contribute to the discussion of contemporary art and culture is a resistance to what I refer to in one essay here as "fundamentalist thinking." By this I mean a view of reality characterized by the division of the world into a set of oppositions. A belief in definitive distinctions between good and evil, victim and oppressor, and insider and outsider, or even in less pejorative opposites like public and private, individual and community, and East and West, goes hand in hand with the assumption that things have a proper order and that a bit of social engineering can set them right. It presupposes, in other words, the possibility of certainty.

There has been a great deal of talk in recent years, particularly from the Right, about the dangers of relativism, which is frequently diagnosed as the disease of liberalism. However, it has become clear that there are equally insidious dangers in certainty and that, moreover, the so-called Left is not immune to its seductions.

Take, for instance, the question of morality as it manifests itself in art. The religious Right has not been alone in demanding that art serve a social purpose. The utilitarian argument also crops up in the postmodern critique – that theory-laden approach to art that was particularly in vogue in the early eighties and that stressed the subversive potential of media-based art. At times it seemed that art that did not self-consciously undermine the viewer's pleasure, belief, and hidden assumptions was not really art at all. In the multicultural era the terms of the debate have shifted, but art remains tied to a utilitarian goal, now defined as the creation of self-esteem among disenfranchised groups.

Or, to turn to more specific examples, take the sanctimonious 1993 Whitney Biennial, reviewed within, which presented the complicated racial, ethnic, and gender politics of the nineties as a simple matter of Us versus Them. (My friend Larry Litt describes this as the gnawing belief that "somewhere out there is a white guy who runs everything.") Or consider the glibness of the postmodern critique of individuality, which considers any assertion of self-expression a fraud, unwittingly complicit with capitalism's all-powerful mass-media, mass-marketing machine. Another example explored in the following pages involves the antipornography feminists who envision the utopian society that will result when men's aberrant sexual

impulses are brought under proper social control. In all these cases, moral absolutes blind their adherents to the possible validity of rival visions and alternative values.

In the essays that follow, I have attempted to locate the middle ground between competing claims to certainty. In the process, I have often had to question my own assumptions. For instance, I have had to square my firm belief in the social and political relevance of art with a growing discomfort over versions of "political art" that reduce it to social work or therapy. I believe that art should be accessible to a larger public, but I am appalled at the way populism frequently becomes a defense of ignorance and philistinism. I applaud the recognition of "difference" but am alarmed when identity is wielded as a cudgel.

I notice that whatever the topic, one question keeps recurring throughout these essays: What is the meaning of community in a world that sees society as a collection of sovereign individuals?

Defined as opposites, individual and community become locked in a confrontation in which neither can win. In a number of the earlier essays I grapple with the prevailing idea that individuality is something we merely "simulate" as we act out our predetermined roles in postindustrial society. Later, in the multicultural debate, the individual reappears but is defined almost entirely by his or her identification with a specific ethnic, racial, or sex based community.

In the debate over pornography, a fundamentalist morality wavers over the efficacy of the individual. On the one hand, he or she is simply the pawn of a patriarchal image culture; on the other, he or she is dangerous because of the untamed individual's capacity for social disruption. Finally, in the section on public art, the question of the relationship of individual and community emerges with particular urgency. If public art is

"for" the community, must the individual artist suppress his or her voice in the interests of social harmony?

Taken together, these examples suggest that many of the most influential voices in contemporary art and culture are increasingly uncomfortable with the idea of individual autonomy. This attack on individualism within the art world would seem to be the antithesis of the apotheosis of the individual currently in vogue in politically conservative circles, where terms like "self-reliance" and "responsibility" are code words for the abrogation of any economic obligation to the rest of society.

Yet, there is a surprising parallel between these ways of thinking. The "simulated" individual of the Appropriation crowd or the group-defined individual of the multiculturalists is as fictive as the sovereign individual currently so beloved of the "Limbaugh conservatives." All these models reflect the kind of all-or-none thinking that reduces the opposition to caricature and makes the vision of culture I argued for earlier in this introduction impossible.

Throughout the essays, I argue for the interdependence of individual and community. Individual freedom is meaningless outside the context of the society that offers the individual an arena in which to act. And, conversely, there is no community unless there is a collection of individuals. The tension between the demands of the individual and the demands of the collective can never be completely resolved. I believe that it is out of this tension that culture grows.

It is much easier to speak the language of absolutes, in which the individual must be all-powerful or nonexistent, and the community the ultimate arbiter of moral value or no force at all. Negotiating the precarious passage between these positions is more difficult and less immediately rewarding. But as the

polarization of individual and group becomes a useful common-place for those who wish to exploit one concept or the other to consolidate their own power, such negotiation becomes all the more necessary. Without a vision of reality that is dynamic and complex, it will be impossible to mount a convincing defense of culture against the demagogues who want to style it as the enemy. The essays that follow constitute my own efforts in this direction.

Movements and Strategies

FROM RECYCLED ART TO DIVERSITY BY DECREE

Appropriation and the Loss of Authenticity

It used to be called "plagiarism." But that was in the days when artists were supposed to have a personal vision painfully forged in the fires of private experience. Then along came Pop and suddenly Campbell Soup cans, Mickey Mouse, and romance comics were high art to a generation of artists for whom subjectivity was bunk. With the eighties, we have finally reached the stage where the very notion of artistic originality is suspect. Today, when East Village enfant terrible Mike Bidlo creates multiple facsimiles of Pollock's Blue Poles (so every country can have one, he says), or turns hero worship into art with the recapitulation of the compositions of Duchamp, Léger, Warhol, and even Schnabel, he is said to be practicing the fine art of appropriation, and his borrowed masterworks find brisk sales in a market where nothing is newer than recycled art.

In New York, from the funky storefronts of the East Village to the spacious showrooms of 57th Street, artists are proudly unveiling paintings that offer an unmistakable sensation of *déjà vu*. Whether it's Sherrie Levine redoing Walker Evans, Egon Schiele, or Arthur Dove, or Bidlo appropriating Schnabel appropriating Rodchenko, art seems to have taken a quantum

leap away from modernism's ethos of rugged individualism. Is this what comes of feeding a generation of artists too many myths and too much indigestible art history? Or is it just the good old American entrepreneurial spirit rising from the ashes of sixties idealism? Nothing succeeds like success, today's young careerists have been told, and they certainly seem to believe it.

For whatever reason, appropriation of imagery would seem to be the tactic of the eighties. (We have tactics and strategies these days rather than art movements – the latter being incompatible with the quick turnover of style that is the hallmark of postmodernism.) Appropriation is culture with an omnivorous appetite, gobbling up every image that wanders across its path. A defining characteristic is that it knows no bounds: high art and low, blue chip masterpieces, corporate logos, sentimental greeting cards, and grisly war footage all become fodder for the insatiable maw. For every Sherrie Levine and Mike Bidlo scavenging from culture's hit parade, there is a Richard Prince rescuing the Marlboro Man from oblivion or a David Salle passing off soft-focus porn as art.

In the beginning, appropriation appeared to be a fairly straightforward spinoff of conceptualism – a way of questioning the concept of originality or exposing the stranglehold of the personality cult on modern art. Today, although such a critical function still asserts itself from time to time, the pervasiveness of appropriated imagery in the work of younger artists suggests that it has somehow been transformed into positive content – the choice of what to crib serving as the eighties version of the signature style.

The fate of appropriation indicates the failure of self-

consciously self-critical art to get under the skin of the dominant culture. Far from being an irritant, the strategy of appropriation has become high chic. On one level, it is just one more trophy commemorating official culture's ability to accommodate anything. On another level, the explosion of appropriated imagery reveals a genuine disturbance in contemporary consciousness.

What is at stake here is the possibility of authentic experience in a world where all our dreams, desires, and fears seem manipulated by external forces. According to Lionel Trilling, the modern ideal of authenticity stands in stark contrast to the older notion of sincerity. Whereas sincerity suggests a way of being in harmony with one's surroundings, authenticity posits a radical disjunction between individual and society. The authentic individual achieves his state not in society but in spite of it, and he is ever at war with the homogenizing tendencies of the group. Since the nineteenth century, one of the functions of art has been to provide both artist and perceptive audience with a space in which authenticity can thrive. The history of modernism can be and has been written as the continual effort of an avant garde to elude the straightjacket of official culture.

The notion of authenticity brought us both the heady romanticism of the heroic outcast, typified by Van Gogh, and the ideal of an aesthetic purity answerable only to its own laws, articulated by Clement Greenberg. Today the wholesale recycling of artistic masterpieces attests to a rejection of both those notions. With the toppling of the gods has come a leveling of values and a conflation of the categories of art, mass culture, and nature. Thus, Sherrie Levine can maintain, "It's no more remarkable to make photographs of a photograph

than it is to make a photograph of a nude or a tree,"[1] and Thomas Lawson can offer as praise of David Salle that "He makes paintings, but they are dead, inert representations of the impossibility of passion in a culture that has institutionalized self-expression. He takes the most compelling sign for personal authenticity that our culture can provide and attempts to strip it, to reveal its falseness."[2]

The argument here is that authenticity is a bourgeois myth foisted upon us in order to divert our attention from our real loss of autonomy. The only art that has any hope of avoiding complicity with the system of oppression, according to Lawson and other neo-Marxist commentators, is a negative art that undermines our confidence in art's ability to transcend its material circumstances. It's much like Dostoyevsky's Underground Man, who can prove his freedom from natural law only by deliberately inflicting humiliations upon himself. Similarly, art can only be art by denying its own power.

For adherents to this view, appropriation becomes a key strategy in the repudiation of authenticity. Reproduction of cherished masterpieces strips away the "aura" of uniqueness that Walter Benjamin claimed characterized works of art in the days before the camera. Out-of-context replications of images generated by the "propaganda industries – advertising, television, and the movies" (Lawson's phrase)[3] expose their blatant attempts to infiltrate our consciousness.

Thus, David Salle's deliberately disconnected pastiches of received images make mockery of our attempts to discover mean-

1. Quoted in Jean Siegel, "After Sherrie Levine," *Arts,* Summer 1985, p. 142.
2. Thomas Lawson, "Last Exit: Painting," reprinted in Brian Wallis, ed., *Art After Modernism* (New York: New Museum of Contemporary Art, 1984), p. 160.
3. Lawson, p. 157.

ing and truth in art. Roger Herman's enormous woodcut versions of the anguished self-portrait of Vincent Van Gogh – patron saint of authenticity – underline the metamorphosis of real man into cultural myth. Lawson, a painter as well as a polemicist, reduces his art to silence as he conceals the appropriated photographic images in his paintings beneath a welter of obscuring brush strokes.

The problem here, as has already been indicated, is that postmodern culture's capacity to assimilate anything makes such subversive tactics into an empty game. When one of Robert Longo's elegant censures of the corporate suppression of individuality serves as the centerpiece of an AT&T advertisement lauding its enlightened support of culture and Leon Golub's grisly Third World torture scenes find their way into the collection of the Saatchi brothers (the British advertising moguls who also brought us Margaret Thatcher), we must begin to wonder if there is any difference between accommodation and opposition.

Perhaps more honest, if not more cynical, is art that acquiesces in its own commodity status. Here, art is seen as a matter of designer labels. When the original designer ceases production, appropriation ensures that someone else is around to pick up the slack. Foremost among appropriators of this ilk is Mike Bidlo, who has re-created textbook examples of the works of Pollack, Schnabel, Kandinsky, and others. For those who missed the great moments in modern art, Bidlo will obligingly re-create them: a party at Warhol's Factory, Pollock urinating into Peggy Guggenheim's fireplace. What is absent here is any sense of the irony that motivates Lawson and his comrades. For Bidlo, art is entertainment, pure and simple. If Camelot can be brought back for endless reengagements, then so can our favorite works of art. Bidlo's Pollocks supply the demand produced by the scarcity of

Mike Bidlo, *Jack the Dripper at Peg's Place*

major works available for sale, and some Bidlo facsimiles have found homes by filling this gap in important private collections of abstract expressionism.

Another variant of this entertainment-oriented appropriation plays heavily on the widespread nostalgia for the Eisenhower era. Kenny Scharf returns his generation to their childhood fantasies, bringing back Fred Flintstone and the Jetsons, along with the comfortable fifties notion that nothing really changes. Prehistory and the future are really just exotic versions of split-level suburbia. Rhonda Zwillinger scavenges fifties postcards celebrating puppy love, the drugstore soda fountain, and the Statue of Liberty and writes them large, embellished with se-

quins and apotheosized into kitsch icons. Walter Robinson re-
vives the lurid covers of sleazy paperback novels.

Since Courbet, the assimilation of popular imagery into high
art has received populist justification as a means of opening art to
the experience of the masses. But there is something disingenu-
ous about the argument that the repackaging of old clichés serves
any democratic or liberating function. Instead, the wholesale
revival of fifties culture (a tendency not limited to the visual arts,
as current developments in fashion and furniture design make
clear) by young artists who were infants at the time suggests an
unhealthy infatuation with the mindless complacency that per-
meated the popular culture of that era. The current appropriation
of fifties pop culture is less an effort to expose the internal contra-
dictions of that era's prevailing stereotypes than to succumb to
the reassuring verities they present. During the fifties, the keep-
ers of culture, people like Hannah Arendt, Theodor Adorno,
Clement Greenberg, and Harold Rosenberg, grew shrill in their
denunciation of the totalitarian impulse they detected in the grad-
ual triumph of mass culture; today it seems bad manners to
dismiss anything or anyone from the pantheon of art.

The new appropriators and their supporters no longer expect
art to shelter the fragile traces of our best possibilities; they do
not even ask that it preside over the ruins in the manner of
Lawson et al. Authenticity as an aesthetic or as a personal goal is
no longer even an issue. Art and its antithesis, kitsch, which
was once identified as the debased commercialization of high
culture, have become one.

In appropriation's final metamorphosis, the image as consti-
tuted by art comes to substitute for the individuality it was once
charged to protect. Borges's short story "Pierre Menard, Author

of the Quixote," originally published in 1956, is a remarkably prescient evocation of this phenomenon. Written in the dry manner of a scholarly review, it recounts the literary career of a certain Pierre Menard, whose crowning achievement was to create the ninth and thirty-eighth chapters of Part One of Cervantes's *Don Quixote*. Menard's goal is to write not a copy, but a new version that would coincide word for word with the original. His task is, of course, complicated by the fact that 300 years have passed since Cervantes's time. The narrator remarks, "To be, in some way, Cervantes and to arrive at Don Quixote seemed to him less arduous – and consequently less interesting – than to continue being Pierre Menard and to arrive at Don Quixote through the experiences of Pierre Menard."

Thus, the new work, although identical to the original, would contain resonances of the twentieth century to the reader aware of its anachronistic nature. The absurdity of Menard's ambition is heightened by the utter seriousness with which his story is recounted. For our purposes, the interesting point is the way in which the work has, in effect, appropriated its creator. Sherrie Levine, doyenne of the appropriators, excerpts Borges's tale in her artist's statements, noting that her version of appropriation is "an appropriation of the desire of the original artist."[4] Levine made appropriation a household word (well, almost) with her (re)presentations of the photographs of Walker Evans. Since then, she has moved on to the masters of early modernism, including Leger, Picasso, Malevich, and Schiele, producing miniature versions of their works in pencil or watercolor. Levine's work is frequently given feminist justification: It is said that she appropriates the male eye, the male desire to

4. Siegel, p. 141.

master the world by reconstituting it in art. Thus she appropriates an illusion created by a point of view that relegates the female consciousness to the realm of nonbeing. Art, which once was a means of projecting oneself upon the world, in Levine's hands now projects its false reality back upon the voided self.

At this point we seem to have reached a point of no return. Appropriation, with its denial of the possibility of authenticity, has reached the state described by Trilling: "we must yet take it to be significant of our circumstances that many among us find it gratifying to entertain the thought that alienation is to be overcome only by the completeness of alienation and that alienation completed is not a deprivation but a potency."[5]

The nihilistic agenda offered by appropriation seems to offer no way out, but in fact it is based on the fallacy of the radical separation of the individual and society. If authenticity can only be achieved at the expense of society, there is no hope for a society that touches every area of individual consciousness. Only if there is a way of achieving authenticity within society can genuine experience be a real possibility. The problem is that art in the modern era has defined itself as a vehicle of self-expression that is meaningful only to the degree that it expresses a private vision. Thus Susan Rothenberg is paradigmatic of the artist who honestly reckons with the problem of authentic expression in the contemporary world. With her fragmented images struggling valiantly against the forces of obliteration, her works express a profound doubt in the communicability of individual experiences.

Dissatisfaction with the alternatives of acquiescence and despair is no doubt behind the new interest in primitive art.

5. Lionel Trilling, *Sincerity and Authenticity* (Cambridge, Mass.: Harvard University Press), 1972, p. 171.

Richard Prince, *Nikki*

Whereas for some primitive art is just another style to be mined for appropriatable images, its appearance at this time also indicates a genuine longing to repair the fractured self through reintegration with the group. For the most part, however, neo-primitivism as an avenue to authenticity has proved to be a blind alley leading only to a futile attempt to re-create a sense of communal identity in a world where that possibility has been eternally and irrevocably shattered.

Nevertheless, there may be a way to chart a course through these stormy waters. Art may be affirmative without being collusive if artists can find a meaningful way to reconnect with the wider social world. In his paean to the humanizing power of art, *On Moral Fiction,* John Gardner wrote, "Most art these days is either trivial or false. There has always been bad art, but only

when a culture's general world view and aesthetic theory have gone awry is bad art what most artists strive for, mistaking bad for good."[6]

Gardner suggests that fiction can be made whole again by the healing power of love, by which he means not sentimentality but an ability to enter into the lives of others. Such an agenda can be glimpsed in the grim but compassionate portraits of Edward Kienholz, the brutally honest yet loving portraits of Alice Neel, and the passionate polemics of Sue Coe.

Art has traveled through rocky terrain since the utopian visions of early modernism. The triumph of the individual and the shucking off of tradition have proved empty victories as we contemplate the possible ruination of our world. The strength of appropriation is that it challenges the blind adherence to modernism's progressive version of history. Its weakness is its failure to offer any alternative to the rule of entropy. Adorno wrote that "To write poetry after Auschwitz is barbaric."[7] And yet, not to write it may be even worse.

6. John Gardner, *On Moral Fiction* (New York: Basic Books), 1978, p. 16.
7. Theodor Adorno, *Prisms: Cultural Criticism and Society,* trans. Samuel and Shierry Weber (Cambridge, Mass: MIT Press), 1967, p. 34.

New-Geo Storms New York

The shop seemed to be full of all manner of curious things – but the oddest part of it was that, whenever she looked hard at any shelf, to make out exactly what it had on it, that particular shelf was always quite empty, though the others round it were crowded as full as they could hold.

Lewis Carroll, *Through the Looking Glass*

Getting a grip on the art world's current craze can be quite as frustrating as Alice's shopping expedition. Despite a breathtakingly rapid rise within months from back room to the Charles Saatchi collection, the New York art world's latest movement/trend/tendency (take your pick) has as yet no name (or, rather, too many names, none of which capture its peculiar ambitions). It has no firm membership roster and no consensus as to what it all means.

Referred to variously as postabstraction, neo-minimalism, neo-conceptualism, poptometry, and (my personal favorite) neo-Geo – geo for geometrical – the work includes Peter Halley's Day-Glo diagrams of cells and conduits, Sherrie Levine's generic Color Field paintings, and Phillip Taaffe's reworkings of both op art by Bridget Riley and abstract expressionism by Barnett Newman (the latter works with a twisted-rope shape substituted for Newman's famous zip). There are also Haim Steinbach's shelf arrangements of digital clocks, ET heads, and lava lamps and Jeff Koons's basketballs floating in aquariums and stacked Plexiglas cases containing state-of-the art vacuum cleaners. Other frequently mentioned club members

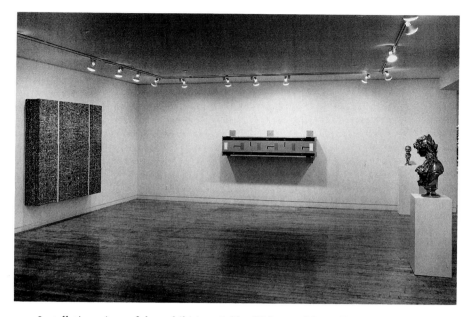

Installation view of the exhibition *Ashley Bickerton, Meyer Vaisman, Peter Halley, and Jeff Koons*

are Allan McCollum, Ashley Bickerton, Jack Goldstein, and James Welling.

In short, the work either mimics earlier "cool" abstract styles or literally "appropriates" classic works, or it simulates the look of slick, buyable commodities or seductive ads – that is, it pretends to be something else.

Formally diverse, these styles are united by their stance toward traditional notions about art as the site of truth, beauty, authentic experience, and original expression. Practitioners are, for the most part, in their late twenties and early to middle thirties; Steinbach, at forty-two, is the graybeard of the bunch. They share a reflex cynicism that seems the special inheritance of the Reagan eighties. Their work borrows the look of high art

(and, at times, the slick formulations of mass marketing and high technology) in order, supposedly, to undermine the foundations on which art (or marketing) is built.

Not surprisingly, given its diversity, this "simulation art" can be packaged in a variety of ways. In several shows last spring it was partnered with the work of old-timers Donald Judd, Robert Mangold, and Robert Irwin, providing it with a genealogy that stretches back to the late modernists. An all-women show at Metro Pictures last winter included several of its adherents in the context of that gallery's focus on deconstructive, media-critical art. Among critics, the "new abstraction's" chameleon-like nature has produced a range of interpretations. It has been seen as a return to visionary abstraction and an extension of appropriation's critique of authenticity. It has been termed a "cool" reaction to neo-expressionism and a cynical ploy to revive a lackluster market.

As Alice might well have remarked, "Things flow about so here." In fact, the only collectors not beset with confusion are the ones who have pounced on this new work with an almost audible sigh of relief. Not since neo-expressionism has art taken such a clear-cut direction. Art professionals may revel in ambiguity, but collectors like to feel they are exchanging hard, cold cash for a piece of history.

The elusiveness of "simulation art" is worth investigating, for, far from being coincidental, the style's resistance to definition is a symptom of its essential emptiness. This work is so hard to see precisely because, to return to the Alice analogy, when one attempts to fix it, meaning skitters away and relocates on the peripheries.

Nevertheless, everyone is trying. Critical discussion is filled with references to death. Hal Foster, in *Art in America,* remarks,

"Painting must die as a practice so that it might be reborn as a sign."[1] Donald Kuspit calls it "dead on arrival" and, in his poetic way, describes its visual appeal: "Its eerie iridescence, like that of many deep sea creatures, seems to bespeak the full force of organic burgeoning, but it has an oddly inorganic crystalline, mineral – aura to it. It is the phosphorescence of decay, creating the semblance of nourishing life."[2] Phillip Taaffe, meanwhile, remarks that his work has "a tragic dimension."[3]

Again, these references are not a side issue. The thread that unites these apparently disparate works is a sense of loss, an acknowledgment that art can never again be full, affirmative, transformational, or even wholeheartedly critical in the modernist sense. Halley, the most articulate of the young pessimists, dismisses the notion of art as a privileged realm of experience. "The geometric art of the '80s mocks the mechanisms of this [transcendental] art-response. [For these artists], there can only be a simulacrum of art, not the 'real thing' resplendent with transcendent significance and referents; only a simulacrum with 'orbital recurrence of the models' (nostalgia) and 'simulated generation of difference' (styles)."[4]

The preceding quotes refer to the writings of Jean Baudrillard, the French theorist whose essay "The Precession of Simulacra"[5] has been taken up like divine writ by the adherents of the new work. Baudrillard argues that, in postindustrial

1. Hal Foster, "Signs Taken for Wonders," *Art in America,* June 1968, p. 86.
2. Donald Kuspit, "Young Necrophiliacs, Old Narcissists: Art about the Death of Art," *Artscribe,* April–May 1986, p. 27.
3. Philip Taaffe interviewed by Michael Kohn, *Flash Art,* October–November 1985, p. 72.
4. Peter Halley, "The Crises in Geometry," *Arts,* June 1984, p. 114.
5. Jean Baudrillard, "The Precession of Simulacra," *Simulations,* trans. Paul Foss, Paul Patton, and Philip Beitchman (New York: Semiotext(e), 1983).

society, reality has been replaced by signs and images that only *appear* to have a connection with concrete relations of power, or with cause and effect. In our brave new world, the "use value" of an object or action is replaced by its meaning as a symbol. Thus, politics become merely a play of symbols of which the most powerful is the nuclear bomb, which exists solely so that it will not be used. Similarly, advertising involves the marketing, not of products, but of the life-style that the possession of these products seems to promise. Borrowing the language of structuralism, Baudrillard maintains that the conventional relation of sign (the word) to signified (the object in the real world to which the word refers) has been reversed, leading to a situation in which, as he says, "The territory no longer precedes the map. . . . Henceforth, it is the map that precedes the territory."[6] Thus we live in the world of the "simulacrum" (Baudrillard's word for the sign that has become detached from its signified), where there is no longer any distinction between true and false, good and evil, subject and object.

Given this situation, the new simulationists argue that art can no longer celebrate the heroic individual, or even art's alienation from crass mass culture, because it has no independent existence or integrity. Art today is literally a shadow of its former self, and strategies like appropriation and pastiche merely expose its degraded role.

Of course, there is nothing new about the charge that capitalist culture inevitably domesticates even the most radical artistic gesture. Duchamp's urinal, meant to challenge the museum system, is now a masterwork. The individualism of the abstract

6. Ibid., p. 2.

expressionists became subverted into an official symbol of American Freedom during the cold war. The antigallery movements of the seventies, earth art, performance, and conceptualism nonetheless made it into the commercial gallery world via their documentation. Leon Golub's grisly mercenaries now grace the walls of the Saatchi Museum.

What is new is the disappearance of that slight moment of independence avant-garde art enjoyed before being transformed into grist for the market mill. Perhaps that moment was an illusion, but even as illusion it gave artists room to move about, the necessary space to keep creation viable.

In the hermetically sealed chambers of the new simulationists, there is no Platonic realm of light where art may breathe a moment before being dragged back into the cave. This is art born corrupt, conceived in original sin, immediately complicit with the powers that restrain it.

At a round table discussion in 1986 at the Pat Hearn Gallery, Steinbach articulated his position: "There has been a shift in the activities of the new group of artists. There is a renewed interest in locating one's desire, by which I mean one's taking pleasure in objects and commodities, which includes what we call works of art. There is a stronger sense of being complicit with the production of desire than of being positioned somewhat outside of it. In this sense the idea of criticality in art is also changing."[7]

This sense of acquiescence, the refusal to be critical, is echoed by Halley, who commented in a 1986 interview, "More and more I try to stop judging and just observe. If I were to start thinking about things like that [the disappearance of individual-

7. "From Criticism to Complicity," roundtable discussion moderated by Peter Nagy, *Flash Art,* Summer 1986, p. 46.

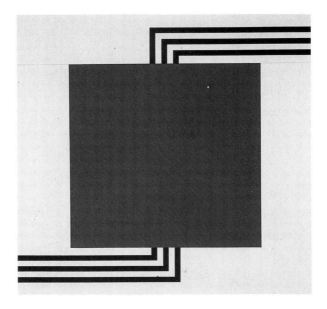

Peter Halley, *Blue Cell with Triple Conduit*

ism and other troubling issues], I would probably be very much against [them]."[8]

Needless to say, these pessimistic sentiments are not shared by all of the art community. Outside of a circle of admirers whose writings have appeared primarily in *Flash Art* and *Arts,* commentators have been sharply critical. The two most considered critiques have come from Donald Kuspit in *Artscribe* and Hal Foster in *Art in America.*

Although Kuspit has for some time been issuing gloomy proclamations about the corruption and cooptation of contemporary art by the "culture industry," he remains a firm believer in good

8. Peter Halley interviewed by Michele Cone, *Flash Art,* February–March 1986, p. 37.

28

old-fashioned transcendence. It may be in short supply even to the point, Kuspit has suggested, that it resides only in the art critic. Yet, nonetheless, transcendence remains the standard of judgment. Its absence in the new abstraction (and other simulation art) leads him to style its practitioners as necrophiliacs feeding off the corpses of vital predecessors. He sees the failure of this work as essentially a moral one: "What has been drained out of abstract art by them is its import for the subject – its attempt to respiritualize and morally re-educate the subject." Refusing this imperative, he charges, all that is left for Neo-Geo is to "thematize the notion of the death of art."[9]

Foster's critique is more equivocal, which is not surprising since, in a sense, these artists are his bastard offspring. Foster, along with Craig Owens and Douglas Crimp, has been a major advocate of the media-critical deconstructive art (which "de-codes" hidden messages of the media by adopting media techniques) that set the stage for the new abstraction. Foster's analysis of the work of artists such as Barbara Kruger, Richard Prince, and Cindy Sherman in terms of their capacity to question notions of artistic originality, subjectivity, and universality underlies the often tortured theorizing of Halley & Co. Foster correctly points out that the new abstraction is an extension of appropriation, not of the "critical abstract painting" of Stella, Marden, and Ryman, to which it bears a superficial resemblance. This being the case, Foster is sympathetic to the new abstraction's aims and philosophy up to a point. He ruefully parts company only when its practitioners reject art's critical function, joining Kuspit in his discomfort with their passivity. He concludes:

9. Kuspit, p. 30.

the use of simulacrum in art remains tricky. Though this use may, on the one hand, transgress traditional forms of art and, on the other, connect the creation of art technically to the production of everyday images, it is hardly disruptive or critical of simulation as a mode. And this mode, though it may undercut representation or free us from its referential myths, is in no simple sense literature. Along with the delirium of commodity signs let loose into our world by serial production, the duplication of events by simulated images is an important form of social control, as important today as ideological representations.[10]

Thus, in the end, Foster, like Kuspit, remains an idealist seeking art that transcends its conditions of production and holds out a glimmer of hope for a better future. Within the magic circle of the new abstraction, such sentiments are seen as willful self-delusion. As Halley remarks, "Along with reality, politics is sort of an outdated notion."[11]

Likewise history. The simulationists are suspended in a present that admits the past only in truncated form. In the Baudrillardian universe that this work inhabits, history is a reinvention of the past to suit present needs. Thus, original intentions do not matter because they are not real. Therefore Halley can merrily rewrite art history to prove the inevitability of his work. According to Halley, Stella is the father of the art of simulacra, a postmodernist despite himself and despite his stubborn tendency to label himself a formalist. Stella, says Halley, is actually mistaken about the meaning of his work because "in the Postmodern situation the artist does not necessarily have the same degree of consciousness that was characteristic of Modernism."[12] The other simulationists, the practitioners of Foster's

10. Foster, p. 90.
11. Peter Halley, quoted in "From Criticism to Compliticy," p. 47.
12. Peter Halley, "Frank Stella and the Simulacrum," *Flash Art*, February–March 1986, pp. 3–4.

"critical abstract art," meanwhile, are the real masters of emptiness, creating geometry as a neutral form. And even the utopian Mondrian, Halley's most obvious spiritual ancestor, in his clean absolutist geometry, is merely a formalist in whose work "the signifier is detached from all meaning, and is thought to be an heroic effort."[13]

Halley presents his own work, by contrast, as full of meaning, albeit the meaning of emptiness. Having thoroughly digested Baudrillard, he offers his own paintings as visual interpretations of the French author's picture of postindustrial society as a network of systems of circulation and mechanistic movement. Halley's flat Day-Glo cells and conduits are intended as models of the systems that govern our lives. Without the artist's theoretical justifications, however, the works appear to be simply rather decorative paintings with a certain kinship to minimalism.

In fact, this decorative quality pervades all simulation art, a fact that may explain the real reason for its rapid acceptance. These works look good. They are generally well crafted, cool, clean. An advocate of new abstraction recently explained to me that "these are objects that look like paintings." He was referring to the fact that the works created under this rubric are themselves simulacra – no more "real" than the illusory reality they expose. Their emptiness is calculated. However, their uncanny resemblance to old-fashioned paintings allows them to enter easily into the marketing and distribution system. Their makers thus have it both ways, positioning themselves above the fray of consumer culture even as they benefit materially from its workings. In Reagan's America – truly the land of simulacra – one can indeed have it all.

13. Ibid., p. 33.

Rehabilitating Abstraction

An authentic work of art is a very mysterious object, which
ultimately has an undeniable reality: making art is alchemy.

George Peck

"Belief in painting" can be a camouflage, a fear of ideas. I don't want
painting to be just an activity which camouflages, which becomes a
bastion for conservatism or the upholding of socially oppressive values.

Ross Bleckner

We've gotten to a point where everything we do feels like a repetition.

Marcia Hafif[1]

In the seventies it was clear to everyone but a few forlorn
formalists that painting was dead. In the early eighties painting
triumphantly resurrected itself in the guise of a new figuration
rising from the ashes of a lifeless abstraction. Today, as we near
the nineties, it appears that this revival was a mere postmortem
reflex and that not only painting but art as we know it is over.

Of course, art has died before. In his catalog essay for the
exhibition *Endgame,* held at Boston's Institute of Contemporary
Art,[2] Yve-Alain Bois points out that the history of modernism is
the history of a longing for the death of art. But what seems new
this time is the enthusiasm with which its unburied corpse has
become an object of delectation. Like the crowds winding

1. Peck, Bleckner, and Hafif quoted in Lilly Wei, "Talking Abstract," *Art in America,*
 July 1987, pp. 91, 84, 96.
2. Reprinted in Yve-Alain Bois, *Painting as Model* (Cambridge, Mass., and London:
 MIT Press, 1990).

through Red Square in anticipation of a glimpse of the embalmed body of Lenin, art world pilgrims make the journey to the temples of Mary Boone, Jay Gorney, and Pat Hearn to pay their respects to an art that is (to quote Jean Baudrillard, until recently its favored philosopher) "already dead and risen in advance."[3]

However, amid the general mourning, a few dissenters have appeared who daringly broadcast the news that reports of art's death have been greatly exaggerated. And, curiously, it is around the issue of abstract art — that apparently moribund approach that not even the frenzy of neo-expressionism could reanimate — that the debate appears to be coalescing.

The crucial move of the pro-life faction has been to separate the history of abstraction from the history of formalism. Against the Greenbergian gospel's demand that abstract art shrug off all extraaesthetic baggage and turn inward to a consideration of the demands of its own medium, recent efforts to rehabilitate abstraction have focused on its initial associations with mysticism, social utopianism, or spirituality.

One watershed of the approach was the flawed but fascinating exhibition *The Spiritual in Art: Abstract Painting 1890–1985,* organized by Maurice Tuchman for the Los Angeles County Museum of Art, which attempted to link the origins of abstraction to the turn of the century fascination with spiritual, utopian, and metaphysical ideals. Another is the ongoing effort by Donald Kuspit to articulate the difference between a dead and a living abstraction and to make a case for the latter's continued viability. Kuspit argues that the health of abstraction bears on the future of art itself. Writing in the September–October 1986 issue of *Artscribe* about the current geometric revival, he notes,

3. Jean Baudrillard, "The Precession of the Simulacra" (New York: Semiotext(e), 1983).

"At stake here is a fight for the soul of contemporary art – a battle between its biophiliac and necrophiliac wings. Both are revivalist arts – postmodernist; the question is whether the geometric style is revived as a moral method or as a chic look."[4]

By framing the question in moral terms, Kuspit strikes a note that sounds distinctly archaic to postmodern ears. Can art really have anything to do with morality these days? Didn't formalism dispose of all that? And was art's moral stance really ever anything more than a feverish delusion?

The problem, of course, is that morality demands an active, conscious agent, whereas the much ballyhooed death of authenticity, creativity, and the self promulgated by the deconstructionist wing of the art world would seem to leave no room for moral action. However, the jolly abdication of responsibility promoted by the so-called Neo-Geos (framed in their discourse as "the embrace of complicity") seems increasingly untenable even to its once most vociferous advocates. A case in point: The most recent manifesto by the New York–based curatorial team Collins and Millazo (which appears in a gallery handout from the John Gibson Gallery) is offered as a critique of their own previous celebration of the art of the commodity icon. Engaging in their customary torture of the English language, the duo describe the rationale for their recent exhibition at Gibson: "In asserting human value over the value of objects as products, The New Poverty reanimates the relation between Self and Other, unconscious and Nature, and reasserts the objectification of these relations through the temporal materialization of objects (in the world) and through the object as instrumentality."

But what form can the assertion of human values take in a

4. Donald Kuspit, "New Geo and Neo Geo," *Artscribe,* September–October 1986, p. 24.

postmodern era? As even Kuspit conceded, the self ain't what it used to be. An art that would deal satisfactorily with its place in the world must take account of the contemporary self's oddly decentered condition as it succumbs to attacks on its integrity by contemporary philosophy, psychoanalytic theory, and Marxist analysis. Which brings us back to abstraction and the reasons why it currently seems such a promising area of investigation.

Before it devolved into formalism and the rhetoric of heroic risk got attached to the questions of the relation of image and edge, abstraction was tied up with the great adventure of the human spirit that was early modernism. On the one hand, it was an expression of the utopian dream. From Malevich to Mondrian to Boccioni, early abstractionists saw their work as the visual counterpart of the great work of social transformation promised by technology, psychoanalysis, or socialism. Paradoxically, as Kuspit brilliantly demonstrated in "Back to the Future" (*Artforum,* September 1985), the embrace of abstraction as an expression of modern dynamism was accompanied by a countertendency to discover through it a way back to the universal, transcendent self whose integrity seemed increasingly threatened by industrialization.

Other commentators have pointed to a relationship between early abstraction's simultaneous insistence on idealized sociability and authentic self-expression and the triumph of capitalism. In his 1937 essay "The Nature of Abstract Art," Meyer Shapiro remarked:

If the tendencies of the arts after Impressionism toward an extreme subjectivism and abstraction are already evident in Impressionism, it is because the isolation of the individual and of the higher forms of culture from their older social supports, the renewed ideological oppositions of mind and nature, individual and society, proceed from social and eco-

nomic causes which already existed before Impressionism and which are even sharper today.[5]

Caught in a bind between its need to express a modernity whose definition of progress was ultimately inimical to individuality and a desire to compensate through denial for what was being lost, abstraction embodied the basic conflicts of the twentieth century. With the dashing of the utopian dream and the disenchantment with heroic self-engagement (which reached its apogee with abstract expressionism), abstraction lost its ambition to mediate between self and world and settled in the postwar years for a peaceful, reasoned formalism.

Cut to 1987. The faces have changed, but the conflicts that abstraction originally arose to express and reconcile are by no means resolved. We are still seeking a meaningful way to exist in a world where God is dead, value is a mere function of profitability, and the individual is apparently just a convenient fiction upon which to prop a mercilessly inhuman order. However, in the late 1980s it is clear that certain solutions are no longer available to us. Although we still revere Mondrian, we dismiss his ambitions – to reconstitute humanity through a revision of its environment – as rash absurdity. Not that we deny the environment's effects on us but, in the shadow of this century's totalitarian excesses, the attempt to consciously manipulate those effects smacks of fascism.

On the other hand, the retreat to extreme subjectivity and the effort to recover a transcendent self seem not only delusional but dangerous – a reinforcement of the ideology of individual-

5. Meyer Shapiro, *Modern Art: 19th and 20th Centuries* (London: Chatto and Windus, 1978), p. 194.

ism that has become the justification for repeated assaults on genuine freedom.

Thus it is not surprising that Neo-Geo, the most heralded manifestation of the revival of abstraction, stresses the absurdity of those early ambitions and allows art nothing more than the power to mimic and illustrate the conditions of our enslavement. Where utopian impulses still exist, they take strange forms. A May 1987 show at International with Monument Gallery featured the work of Zvi Goldstein, an Israeli-based artist who borrows the form language of advanced technology to create sleek, futuristic constructions. These are intended, according to the artist in his handout for the exhibition, to present "the conceptual foundations of future languages" through "a preparadigmatic model for an alternative concept of progress." Despite these lofty ambitions, the works speak more to today's neominimal aesthetic than to the future's need for new modes of communication. And it is hard to imagine that even the artist really believes these handsome objets d'art will ever reach any audience beyond the confines of the art world.

If Neo-Geo and its discontents are the impotent and distorted reflection of early abstraction's social and utopian aims, recent efforts to promote a new spiritual abstraction represent the late-twentieth-century's mystical side. Gold leaf, black crosses, mysterious encrustations of black tar and wax, and tantric circles have come to function less as inducements to a state of contemplation and spiritual communion than as mere signs of the desire to display spiritual content. From its inception, abstraction has been haunted by a Platonic dream of uncovering the "real" by a ruthless elimination of particulars. Unfortunately, events have demonstrated that the most "absolute" and "universal" symbols are

historically and socially constituted. Even Euclidean geometry – which has inspired so many artists to "timeless" and "essential" art – is only one of a smorgasbord of geometric systems now offered by modern mathematics. Nor, in an era when even physics has abandoned the notion of a purely external, unmediated reality, can a longing for eternal truths and transparent communication seem anything but nostalgic. Thus, it is hard to buy Kuspit's plea for the new spiritual abstraction when he argues, "The symbols used by spiritual art are another form of the elemental return, another proof that the spirit has stable modes of appearance, however such modes may, for the uninitiated, seem purely material and mechanical."[6]

The problem with the current debate over the possibilities of abstraction (which has become, by extension, a debate over the possibilities of art) is that it has become polarized between the two poles represented by Neo-Geo's simulated self and the new spirituality's transcendent self. Unless one is willing to accede to formalism's hands-off position, there seems no middle ground. Yet if abstraction is to remain viable, it needs to reconcile these positions. The question arises: How can abstraction engage with the contemporary experience of a threatened but not yet (Peter Halley to the contrary) completely annihilated self? If we concede the fact that abstract symbols and forms are conventional rather than universal, must this render them necessarily meaningless? What sorts of truths, if any, can abstraction hope to convey?

The future development of abstraction requires our acknowledgment that we speak in a language that precedes us – that the

6. Donald Kuspit, "Concerning the Spiritual in Contemporary Art," *The Spiritual in Art: Abstract Painting 1890–1985*, Los Angeles County Museum of Art (New York: Abbeville Press, 1985), p. 324.

Ross Bleckner, *Departure*

symbols and forms it employs can never offer an original and unmediated expression of pure feeling (since we can never conceive of our feelings independently of the conventions of feelings we have learned). Nor, because this language is arbitrary, can abstraction put us in touch with eternal verities. To say this is simply to admit that we exist in community – that the iso-

Elizabeth Murray, *96 Tears*

lated individual is a myth and that whatever meaning our self-hood has, it is a meaning that comes from existing in the world. Thus, an abstraction that takes into account the conditions of our existence would acknowledge the conventional nature of the language it uses without letting that knowledge paralyze its efforts to communicate.

One artist who seems to be thinking in these terms is Ross Bleckner. Although often categorized with the Neo-Geos, he avoids their blanket rejection of expressive content. He re-

marks, "Emptying out is not really emptying out. It is the bringing of new meanings into existence, the opening up of old meanings."[7] His paintings are informed by references to aesthetic conventions – from op art and geometric abstraction to the mystical chalices and trophies – but they are presented with a strange self-conscious conviction that oscillates between belief and its opposite.

Another is Elizabeth Murray, who twists certain conventions of formalism – the shaped canvas, the relation of image to edge and objectness to illusion – so out of shape that they are forced to readmit the teeming complexity of the social world.

This is not the place for a prescription for the future development of abstraction. It is, however, a plea for the idea of a future at a moment when it seems very fashionable to deny that art may have one. In his "Endgame" essay, Yve-Alain Bois suggests that we look at the matter in the light of game theory. He proposes that what we have recently experienced is not the end of the game of art, but the end of a particular play within the game. Thus, he concludes, "the end of the end is over (hence we can start again on another play). . . . Painting might not be dead. Its vitality will only be tested once we are cured of our mania and our melancholy and we believe again in our ability to act in history."[8]

7. Bleckner quoted in Wei, "Talking Abstract," p. 84.
8. Bois, p. 243.

41

Social Responsibility
and Censorship

Breaking into what was otherwise promising to be a desultory season, the censorship uproar seems to have galvanized the art world in a way that has not been seen since the much ballyhooed resurrection of painting in the early eighties. There are marches, panels, articles, editorials, and scores of exhibitions devoted to obscene, sacrilegious, or otherwise objectionable art. Having at long last found a cause to rally around, the art world is enjoying a rare consensus about its own importance as the last bastion of free expression in an increasingly censorious society. Still, there is something troubling in all the self-congratulatory rhetoric floating about. There is too little curiosity about the underlying causes of this situation, too few questions being asked about the lack of general interest in the art world's fight for artistic freedom, too much business-as-usual jostling to use the current controversy as a career-building strategy.

I am certainly no supporter of Jesse Helms, and I think that few rights are more important than freedom of expression. I am also aware that there are deeply cynical motives behind Helms's attack on Mapplethorpe and Serrano, among them the advancement of his own career and the desire to junk the NEA alto-

gether. However, it is important to keep in mind that his attack has been so successful because he has aligned himself with forces already in motion – as the removal of Richard Serra's *Tilted Arc* this fall and the pair of censorship flaks at the School of the Art Institute of Chicago demonstrate.

There is a reason why these attacks are coming now – and it is only partly because the far Right has seized on culture as its new political battleground. The attacks also represent the explosion of tensions long existing between the art world and society at large, tensions that originate in the contradictions inherent in wanting to have it both ways – to be allowed total artistic freedom (which generally translates into contempt for the philistine public) while enjoying public support for the arts.

The recent attacks have brought out all the old clichés about the value of art as "an essential component of our civilization," the "conscience of society," and so on. And yet, any casual survey of the contents of galleries and contemporary art museums reveals that the vast majority of work on display has less to do with the expression of eternal or difficult truths than it does with fitting into the categories of high-priced collectibles or light entertainment. For decades, the art world proper has resolutely separated itself from any sense of responsibility toward the social world, which makes the humanistic terms with which it defends itself now more than a little suspect.

The *Tilted Arc* controversy, which in many ways served as a harbinger of recent events, illustrates the double-think that has so long governed the art world. As a piece of sculpture, there is much to commend *Tilted Arc*. As a piece of public art, it was remarkably wrongheaded – the product of the artist's desire to treat the plaza as an abstract space regardless of its function and meaning within the urban fabric. When local residents and

workers pressed for removal, the art world lined up unanimously behind Serra, condemning the know-nothings who would have preferred a fountain and benches to a 120-foot wall of steel. One of the most instructive aspects of this controversy is how little weight was given to the claims of the users of the plaza; untrammeled artistic freedom became the ultimate value before which all other social considerations had to fall.

Hans Haacke, meanwhile, has made a career of pointing up the art world's convenient moral blindness to larger social considerations, focusing on the willingness of major art institutions to assist in the whitewashing of corporations whose practices have questionable economic, social, and political consequences. In case after case, he has documented how such issues as apartheid, cancer risk, and toxic waste are conveniently overlooked when sponsoring institutions like Mobil, Phillip Morris, and Alcan are willing to put up money to sponsor art exhibitions and projects. The Serra controversy and Haacke's investigations both point to a convenient double-think that pervades the art world, in which "the enhancement of life" translates into making a bleak plaza bleaker for already beleaguered urban workers and "the conscience of society" can be purchased for a few institutional grants.

In a poll of museum directors on the censorship issue recently published in *The New Art Examiner,* Lynne Warren of the MCA in Chicago was the only one to acknowledge that the art world might bear any responsibility for its current predicament. She asked:

Did the arts community really believe it could "reach a broader audience" without having to stop and think maybe that broader audience wouldn't really know how to decipher those often morally bankrupt, cynical, obscure, self-referential, and downright self-indulgent prod-

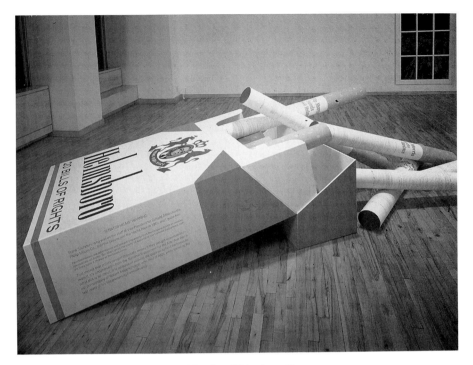

Hans Haacke, *Helmsboro Country*

ucts contemporary artists are spewing forth? Or does the community believe that because the jaded, safe, thrill-seeking (c.f. "safe sex") New York art world thinks Robert Mapplethorpe's sadomasochistic imagery is the cat's meow, the public-at-large should swallow it whole (pun intended)? Or that a conservative Christian will stop himself and say, "No, I won't judge Mr. Serrano's 'Piss Christ' until I've understood it in context." The arts community has often been accused of being morally lax and socially arrogant; it seems the chickens are finally coming home to roost.[1]

Such voices are rare at the moment. More typical is the spectacle I witnessed this fall at a panel on censorship organized by the

1. "Against Intimidation," *New Art Examiner*, October 1989, p. 27.

New Museum. After an informative series of statements by representatives of some of the organizations that have been on the front lines, the floor was opened for discussion. One after another, artists got up to use the forum for various private agendas – promotion of their own work (the ever tiresome, "I did it before Mapplethorpe and Serrano"), passionate statements about artists' right to subsidy, and so on. Finally, a young woman got up and posed what should have been the real focus of the discussion: How, she asked, do you justify this kind of work to the nonart public? What kind of education or outreach could be employed?

But before the panel could begin to address her question, another artist grabbed the microphone and launched into a dissertation on the erotic pleasures of Mapplethorpe's work. I left soon after and ran into the young questioner in the hall, as frustrated as I was at the frenzy of self-aggrandizement we had just witnessed.

If anything more is to come out of the current censorship flap than a warm feeling of moral superiority over the ever obtuse masses, we in the art world need to take stock of our position vis-à-vis the rest of society. Does, in fact, the majority of art being made today have any significance to anyone outside the tight circle of collectors, dealers, artists, curators, and critics who make up the current art system? If it doesn't, how can we continue to maintain, as Robert Brustein did recently in *The New Republic,* that "every artist has a First Amendment right to subsidy"?[2]

It is true that a certain veneer of social concern is highly fashionable in art at the moment. However, the most (commer-

2. Robert Brustein, "The First Amendment and the NEA," *The New Republic,* September 11, 1989, p. 29.

Ronald Jones, *Untitled (New Human Immunodeficiency Virus Bursting from a Microvillus)*

cially and critically) successful of such efforts tend to be couched in sufficiently sophisticated postmodern form as not to alienate those potential collectors who may benefit from the inequities to be exposed. A pair of cases in point: Ron Jones's recent AIDS show, in which the shape of deformed or diseased body cells became the basis for elegant, Brancusiesque sculptures, and Ashley Bickerton's nod to the current fashionability of environmental concerns with the exhibition of a set of slick, high-tech "time capsules" containing materials from the rapidly disappearing natural world. In both cases, real issues became mere fodder for the creation of highly commercial art objects. The current brouhaha has unleashed a lot of rhetoric about risk taking and art on the edge, but we need to keep our perspective about just what that means. In the United States, risk taking means accepting the dangers of grant cutoffs or career damage. In countries like China or Iran, it means literally putting one's life and liberty on the line.

Having long absolved itself of any real moral or social responsibility, the art world is in a poor position to take the high ground now. The specter of censorship and the authoritarian agenda of the far Right are truly alarming. But if we want to convince society that freedom of artistic expression really matters, we are first going to have to start believing it ourselves.

Art in the Nineties:
A Mixed Prognosis

A few short months into the new decade, the eighties already seem a distant memory. The buzzwords of the day – "trickle-down," "luxury condo," "DINK," "LBO," "Yuppie," "simulation" – have a quaint and rather tarnished ring, although it is not yet clear, as the ground seems literally shifting beneath our feet, what will replace them.

There are still those who laud the Reagan days as a period of unprecedented growth and prosperity. For those of us with incomes under $100,000, however, it is clear that that glittering façade concealed a multitude of ills. Any number of events could be chosen to mark the passing of an era – the fall of the house of Drexel, Burnham, Lambert, the failure of Campeau, the dethroning of Leona Helmsley, the Housing and Urban Development revelations, even the war of the Trumps.

Each of these dramas has the aspect of a contemporary morality play, revealing the unpleasant consequences of indulgence and greed when they are left free to develop unchecked by the natural restraints of commonality, social responsibility or, at the very least, good old-fashioned government regulation. Much of our government's attention these days seems focused on the

growing lawlessness of the drug culture, but it is clear that the disrespect for law in the streets of America was more than matched during the eighties by a disrespect for it in the nation's corporate boardrooms and government offices.

For a while, the philosophy of greed seemed to work, at least for some. But today, as Wall Street whiz kids join the unemployment rolls and Leona Helmsley prepares to check into rather less queenly quarters, privilege no longer seems the ultimate protection.

What will the nineties have to offer? With the orgy over, are we in for a decade of grim austerity and bitter turf battles? Will we find, as we shake ourselves awake the morning after, that egotism and greed have become so entrenched that they have supplanted all of our better impulses? Or will the crises of the nineties rekindle an almost extinguished sense of common cause?

One of art's more useful qualities is the light it sheds on the state of the culture. In the eighties, art, or at least that portion of it that was most visible in galleries, in museums, and on the pages of glossy art magazines, seemed largely a creature of the economic boom. Such odd mutants as Born Again painting, resurrected from the ruins of modernism for the nourishment of a Born Again market, the return of the heroic artist in a mold that complemented the new fashion for the swashbuckling entrepreneur, and Neo-Geo, whose dual rhetoric of critique and complicity formed the perfect mirror for eighties-style liberalism, could only have been possible in the hothouse atmosphere of the Reagan era. Even the arcane language of criticism, which one might expect to be so removed from the mundane world of dollars and cents as to be irrelevant to it, played a role in legitimizing the flight from social consciousness. For despite its derivation from

Marxist thought, the World according to Baudrillard, with its replacement of concrete reality by the "forest of signs," in the end provided perfect justification for the transformation of politics into image manipulation.

As we settle into the nineties, the art world seems to be undergoing one of its periodic shifts. Interest in the kind of theory that brought us "hyper-reality," the "simulacrum," "hover culture," and their brethren seems on the wane. (A small but telling indicator: Whereas an entire bookcase of the New Titles section at the East Village's ultra-hip Saint Mark's Bookstore used to be devoted to Baudrillardian musings on postmodernism and consumer culture, such titles are now being crowded out by books on Third World women, the politics of AIDS, the origins of psychoanalysis, and other such topics.) It seems likely that the declining popularity of eighties-style theory may be linked to the fact that many of the entities that it attempted to theorize out of existence have turned out to be stubbornly real. Nature and the body, for instance, may be social constructs, but developments like AIDS, ozone depletion, and the hazards of toxic waste suggest that they may have some concrete existence as well.

As the theory of simulation fades in importance, so does the once de rigueur focus on art's commodity status and its complicity with consumer culture. Instead, a growing number of artists and galleries are presenting work touching on environmental and body themes. On one end of the spectrum are artists like Ashley Bickerton, whose latest pieces of hardware carry an ecological message, and Ronald Jones, who recently presented a series of elegant Brancusiesque abstract sculptures based on the forms of diseased human cells, for whom these subjects seem merely the latest fashion.

Ashley Bickerton, *Minimalism's Evil Orthodoxy Monoculture's Totalitarian Esthetic #1*

Other artists seem to have a more serious commitment to the issues. Mierle Ukeles's long in the works *Flow City,* for instance is an installation slated for completion in 1992 that will provide public access to New York City's new Marine Transfer Station. Alfredo Jaar's recent installations explore the international politics of waste disposal, focusing on the dumping of American-generated toxic waste along the Nigerian coast. Others work in a more poetic vein. Mary Lucier's video installations touch on the dichotomies between the idealized landscape of art and the realities of the industrial transformation of nature. The site

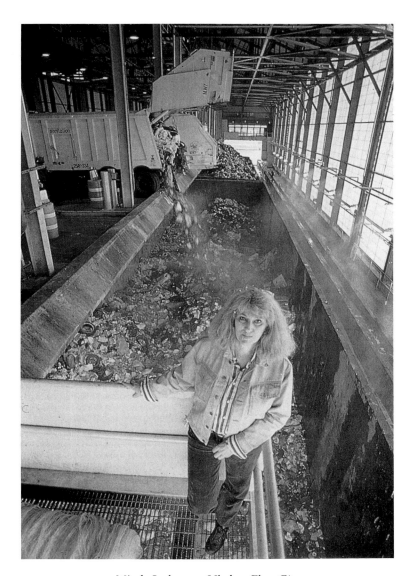

Mierle Laderman Ukeles, *Flow City*

works of Mary Miss, such as her remarkable environment along the shoreline of lower Manhattan at Battery Park City, blur the distinction between nature and culture.

Artists working with the body range from Dorit Cypis, whose installations and performances attempt to cut through the culture's idealized female body to the real, imperfect organism beneath, to artists like Robert Gober and TiShan Hsu, whose peculiar sculptures are body objects that mix references to tissues and organs with references to sinks, tubs, and medical and domestic environments in order to suggest how dependent modern human life has become on artificial support systems. There are as well numerous artists dealing directly with the issue of AIDS, among them David Wojnarowicz, Nan Goldin, and Nicholas Nixon.

Another possible indicator for the nineties is the emergence of multiculturalism as a force to be reckoned with both inside and outside the art world. In part, this reflects the simple fact of the growing ethnic diversity of the American population and the increasing interdependence of all strands of the world economy. There are as well the remarkable events of 1989, as governments topple in the wake of popular demands for political independence and self-determination. And finally, in academic circles, the popularity of deconstruction has led to a reconsideration of all systems of order, whether they comprise gender roles, political ideologies, or once inviolable academic canons and standards.

The result has been a shift of attention to those entities, peoples, or value systems that formerly seemed peripheral. In a word, the Other is in. In the art world this has manifested itself in the proliferation of exhibitions that focus on multicultural themes; on the art market's acceptance of such new categories as Russian art, Latin American art, Japanese art, and so on; on the

increasing prominence of artists like Lorna Simpson, Adrian Piper, Robert Colescott, and Joe Lewis, who deal specifically with questions of racism and prejudice; and on an increasing awareness that the categories of modernism and postmodernism are too limited to contain the real diversity of contemporary art production.

However, although this new openness is all to the good, it does contain hidden dangers. As the center gives way, it appears that some Others are more Other than other Others. A divisive rhetoric of separatism sometimes accompanies efforts to promote work by formerly excluded groups, as if there could be no communication across gender or ethnic lines. Nowhere is this clearer than in current debates over the composition of high school and college curricula. While Allan Bloom calls for a rigid canon of standard works, radical feminists discard the works of William Shakespeare as mere propaganda for patriarchy, and a report on multicultural education issued in the summer of 1989 by the New York State Department of Education accuses the state high school system of "intellectual and educational oppression" of minority students through "a systematic bias toward European culture and all its derivations."

The polarization developing around these issues is disturbing. Is it only possible to redress the white ethnocentric bias of our educational and art systems by discarding Western culture wholesale? Will we not all be diminished if we conclude that only women authors are relevant to women readers, black authors to black readers, and Native American authors to Native American readers? If, as deconstruction has demonstrated, no values are universal, does that mean that no values can be shared?

This is not merely an academic question. Racial questions seem poised to turn our major cities into armed camps, while

internationally, the resurgence of nationalism threatens the stability promised by the dissolution of the cold war. In the art world, the separatist mentality creates antagonisms between groups that might more fruitfully work together. And although it may be illuminating to point out the exclusionary structure of the current art system, this energy might be better spent on the more important task of circumventing or changing it.

Which brings us to a third possible indicator for the nineties – the growing move to go beyond the fashionable salons created by the commercial galleries. An encouraging development over the last decade has been the emergence of a kind of "social sculpture," a public art that takes the meaning of that term seriously and attempts to grapple with issues of tangible social, political, and economic importance in a space frequented by non–art world types. Among the more visible practitioners of this mode are Krzysztof Wodiczko, Dennis Adams, Jenny Holzer, Alfredo Jaar, and Vito Acconci. Such a development, of course, could easily be stifled if the politicization (pursued, oddly enough, under the guise of depoliticization) of the NEA continues, since noncommercial projects of this nature often depend on government support.

The nineties, then, come to us with a mixed prognosis. Hints of a resurgence of social conscience and global thinking mingle with symptoms of isolationism and factionalism. As the threat of nuclear holocaust recedes, the dangers of ecological disaster, overpopulation, and nationalism loom large. For artists, as for society at large, the choices in the nineties oscillate between withdrawal and engagement, a retreat into a fantasy world of easy scapegoats and simple answers, or a commitment to hard thinking about complex problems. Beyond that, the crystal ball fades and the real work begins.

Aesthetic Quality,
Artistic Control

In the spring of 1992, I attended a symposium entitled "Tolerance as an Art Form." Sponsored by the New York Department of Education, it was devoted to an exploration of the ways in which art could be employed to bridge the racial, ethnic, and cultural divides that seem to be opening up between so many groups in our cities. It would be hard to think of a more laudatory aim for art, yet as the paeans to the cross-cultural programs of institutions like the Jewish Museum and Brooklyn's Children's Museum began to build and the references to artists as consensus builders, healers, and mediators began to proliferate, certain members of both the audience and the panels began to grow uncomfortable. Finally, two panelists broke from their prepared remarks to address their unease. Choreographer Bill T. Jones took issue with the idea that art is an unthreatening way to bring people and their respective areas of diversity together, stating, "It's not safe. It should not be safe. It should not be nonthreatening. It should be in your face, right?" William P. Honan of the *New York Times* concurred, noting, "Very strange things happen when the government or the academy or what-

ever it may be asks artists to perform in a certain way and begins to direct their activities."

This discussion reminded me of another conference I had attended several months before in Chicago. Sponsored in connection with *Culture in Action,* the recently completed series of public projects orchestrated by Mary Jane Jacob, the conference included a series of discussions and workshops on issues raised by the project. Jacob had invited various socially concerned artists to spend time in Chicago working with a disadvantaged community of their choice to create an artwork that would enlarge the definition of art while empowering the communities with which they collaborated. At the conference, there was a great deal of discussion about the character of (and necessity for) art that privileges process over product in an effort to revitalize the public art arena. Artists characterized traditional notions of genius and quality as patriarchal, ethnocentric, and imperialistic. One artist, who was particularly strident in his condemnation of "high culture values," noted that he saw it as his function in this project to serve as a conduit for releasing the voices of the members of his collaborative group. As in the "Tolerance as an Art Form" symposium, it was clear from the question-and-answer sessions and the discussions that followed that many audience members were troubled by the larger implications of what they were hearing, and that they were less willing than many of the artists to jettison conventional ideas about aesthetic quality and artistic control.

Although it is hardly likely that the New York Department of Education was attempting to assume the role of cultural commissar, or that the artists in *Culture in Action* really meant to dissolve all semblance of artistic choice and individualism, both incidents are troubling for what they suggest about some assumptions

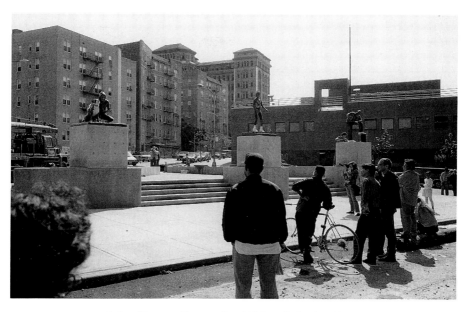

John Ahearn, *Raymond and Tobey, Daleesha, Corey*

currently afloat in the art world. One could cite other cases – the
presentation of a Whitney Biennial in which art often seemed
indistinguishable from therapy, for instance, or the increasing
number of incidents in which community groups have forced
public artists to remove or alter their work because it is deemed
damaging to community members' self-esteem. (A case in point:
John Ahearn's decision to remove a trio of community-approved
public sculptures in the Bronx because, after the artworks were
installed, several vocal community leaders complained that they
did not reflect a sufficiently uplifting vision of that downtrodden
community.) What all these examples have in common is an
assumption that art in a democratic society should be essentially
indistinguishable from any other kind of social program replete
with an appropriate political agenda.

Although I have long been interested in art that deals with social and political issues, I can't help feeling that the art world is in danger of being derailed by good intentions. I fear that William Honan is right – there is an eerie similarity between the rhetoric of government-sponsored social realism (the sort that has just recently been abandoned in former communist countries) and the demands that art serve as an instrument of social conditioning under the benign label of "tolerance." Meanwhile, the insistence by community groups that public artworks in effect idealize their members so as to encourage positive self-images seems in danger of bringing us back to the bad old public art (read traditional, white, male) figures that cultural Others are so pleased to have replaced. Perhaps the time has come to look more critically at some of our current sacred cows.

What I would like to propose here is not any concrete answers, but merely a series of questions that I myself have been struggling with in these confusing times. First, we might ask what we really mean by buzzwords like "access" and "diversity." The multicultural mania has sent foundations and institutions scrambling to increase the ethnic, racial, and sexual diversity of their programming. Although this is all very commendable, little notice has been taken of the fact that the real exclusions inside and outside the art world today fall along the line not of race, gender, or ethnicity but of class. The current economic crisis is making what was already a largely middle- or upper-class art world even less accessible to those without money for art school, to supplement the low-paying jobs and nonpaid internships that provide entry into art careers, and for the escalating rents and studio expenses that make it possible to work. The art world has always been a privileged place, and so it remains. I am beginning to infer

that the current preoccupation with identity simply camouflages the more entrenched and hidden division of class.

This leads me to question art's current societal role: Should art's place as a preserve of free expression be safeguarded or should art be employed to create a new social order? Although both seem part of the current progressive agenda, ultimately they are ideological goals that are almost by necessity in conflict – each presenting the polar opposite of the other's end. Are we willing to accept the consequences of either one of these social agendas for art – to defend art that presents a variety of abhorrent views (can we honestly defend the misogyny and desensitizing sentiments of certain rap lyrics, for instance?), on the one hand, or rule certain subject matter or points of view taboo, on the other? Bearing this in mind, I am troubled by the fact that there seems virtually no difference between the Right's demand that art reflect so-called societal values – family unity, respect for religion, and the like – and the Left's demands that art promote tolerance and self-esteem.

It seems that those of us who are interested in art's potential for social transformation must be clearer regarding our objectives. Do we want art that is disruptive or harmonizing? Should it build bridges or shake us up? Should it express a community or individual vision? Can an artist be too accommodating (as in the Ahearn case)? Does art suffer when it is instilled with an agenda? Is something lost when art begins to approximate the models of social work and therapy?

Robert Hughes has argued that Americans have always held a utilitarian vision of art. From expression of religious sentiment embodied in the American landscape tradition, to the argument that art provided a civilizing element for a frontier society, to the current vogue for an art of social protest, we have laid a

burden on art that may be impossible to sustain. But if we allow art to break free of the Platonic triad that equates the Good, the True, and the Beautiful, what is left for it to be?

Finally we must ask: What is art's relation to morality? Liberal rhetoric is so easily subverted for its opposite end: The catch phrases of liberal tolerance have often been used to support anti-liberal ideas like the implementation of hate speech rules on campus or the feminist campaign to outlaw pornography. Hence professions of tolerance lead to positions of intolerance. We must avoid the seductions of utopian thinking. The belief that right-thinking people can force a rational world into being is at once one of the most attractive and dangerous of notions. I sense that it is behind a great deal of the most stridently political art today.

Realistically, the world is not so starkly divided into oppressors and victims as some of the most popular purveyors of political art would have us believe. We might learn more about our current problems if we are able to see them from a variety of points of view. Unfortunately, it is difficult for confusion and complexity to stand firm against the powerful force of certainty and polemic.

I'm not sure where we go from here. As one who has always been in great sympathy with art that enlarges our sense of humanity, sharpens our sense of moral outrage, or uncovers the social unconscious, I find myself oddly uncomfortable with the current vogue for identity politics, social agendas, and communal art making. Is the eccentric, individual vision really so reactionary? Are aesthetics really antithetical to political conviction? We live in a peculiar time when a sense of certainty may be one of our worst enemies. The most valuable art today may be that which operates, not as a declarative, but as an open-ended, thought-provoking question mark.

Analyzing the System

COMMERCE AND THE CRITIC

High Priest or Media Flack?

THE ART CRITIC IN THE AGE OF HYPE

What has gotten into art critics these days? Are they suffering from battle fatigue brought on by tramping through 400 shows a month? Are theories a couple of sizes too small pinching their shoulders? Are they tired of drinking bitters while everyone else sips Champagne? Whatever the reason, it sometimes seems that they haven't a nice thing to say about contemporary art, the state of the art world, or each other. Recently, Carter Ratcliff isolated two species of critics and dubbed them the Cassandras and the Grouches, a pair of appellations that captures the note of soured idealism that permeates the critical camp. Donald Kuspit proclaims that because art has lost its independence, the critic is the only real artist left. Barbara Rose writes for *Vogue* as she decries the degeneration of art into entertainment. Suzi Gablik turns mystic. Hilton Kramer carries on a search for Marxists behind every paint pot. And in *Art in America,* the Holy Trinity of Owens, Foster, and Crimp deliver virtually readerproof dissertations on the conquest of art by the market.

Why do critics feel so dispirited? Twenty-five years ago, Clement Greenberg wielded the power to shape an entire art movement. Ten years ago, Lucy Lippard confessed that although she

abhorred the system, she continued to write because it was a way of bringing forward the work of women artists. Today, critics seem fascinated with their own impotence. Are they simply being disingenuous, or are larger social, economic, and political forces conspiring to render their calling irrelevant? How do the circumstances under which criticism is done today affect the results? Is the cynicism of certain critics the logical consequence of such eighties phenomena as instant masterpieces, disco art, and celebrity collectors?

Several years ago, in an article in the *Village Voice* on art and power, John Perreault remarked, "My current theory about what's wrong with the commercial art world is that the support system for art, a complicated mechanism of checks and balances, is askew."[1] In a recent interview, he elaborated: "The support system is now geared to collectors and not artists. We [the critics] used to be on the side of artists and art. Now most critics seem to be the servants of collectors. I'm not against artists selling their work – I think – though I'm starting to wonder about that, but this [system] is putting the cart before the horse."[2]

As if to illustrate these charges, a recent item in the *New York Times* announced the establishment of a foundation by real estate entrepreneur and art collector Francis Greenburger. The foundation will award grants to underrecognized artists selected each year by a jury consisting of a prominent artist, a dealer, a collector, an art critic or historian, and a museum director or curator. Admirable though this idea may be, Greenburger expressed his motivation in terms that cast light

1. John Perreault, "Power/Critics," *Village Voice,* October 18, 1983, p. 81.
2. Interview with the author, January 1986. (Unless otherwise noted, quotations are from interviews with the author.)

on how today's collector views the function of art world professionals. The *Times* quotes Greenburger as saying:

As a collector, I'm interested in finding artists who are not the brand names. It's like going on a treasure hunt. In a sense this is a deliberate way of asking the various jurors: who do you think is around who is an interesting talent that I should go look at? I can't help but believe that other collectors wouldn't feel the same way, that perhaps this was an inside track.[3]

Reduced to talent scouts for big collectors, contemporary critics may be forgiven for their vile mood.

Of course, the identification and promotion of new talent has been part of the critic's task since the days of Baudelaire, Mallarmé, and Apollinaire. However, the promotional side of art criticism did not really become troubling until the idea of art as investment began to take hold in the mid-sixties. Robert Hughes points out that the inherently irrational nature of art as a commodity – its value having no relationship to its function, material contents, or labor – has called into being "a huge and complicated root system in scholarship, criticism, journalism, PR, and museum policy."[4] The development of this system and the relegation of the art critic to a niche within it is one of the key facts of the contemporary art critic's existence.

The rise of the East Village illustrates how total the critic's absorption by this system can be. Young artists, driven by high rents to the drug-ridden streets of the Lower East Side and frustrated by the inaccessibility of SoHo galleries, created their own art scene in tiny storefronts on the Alphabet Avenues. By and large untroubled by scruples about capitalism

3. *New York Times,* February 18, 1986, section III, p. 17.
4. Robert Hughes, "Art and Money," *New Art Examiner,* November 1984, p. 33.

and bourgeois ideology that had plagued the old avant-garde, this generation of artists shrewdly studied the hype machine to discover how it could best be manipulated. In the early days of the East Village, people drifted easily from role to role, switching effortlessly between artist, dealer, critic, curator, and collector. The critics who emerged as spokespeople for the East Village, notably Carlo McCormick, Walter Robinson, and Nicholas Moufarrege, were seen and see themselves primarily as promoters.

Carlo McCormick now writes for *Artforum* as well as the *East Village Eye*. Unlike many of the critics interviewed for this article, he still believes in the influence of the critic. "There seems to be a ladder of power in the art world, and the critic occupies one rung of that ladder," he says. This confidence seems grounded in his conception of the critic's role. "I act as a rooting section . . . I see myself as an advocate." He adds, "I love turning a gallery on to an artist."

More common is the attitude of Jeff Perrone, who, after over ten years of writing criticism, has decided to move on to other pursuits (which he coyly refused to specify). He says, "You have automatic power if you walk into a gallery and have five million dollars to spend. When there are people like that around, who needs critics?"

To a certain extent, carping about money is as old as art criticism. In his "Salon of 1859," Baudelaire voiced a startlingly contemporary complaint:

Despite his lack of merit, the artist is today, and for many years has been, nothing but a *spoiled child*. How many honors, how much money has been showered upon men without soul or education . . . while good poets and vigorous historians make their livings with extreme

difficulty, the besotted business-man pays magnificently for the indecent little fooleries of the "spoiled child."[5]

In a similar mood, Bernard Berenson recorded in his diary his resentment toward collectors and dealers who exploited his expertise for their own profit:

The idea of private gain scarcely entered my head at first and for a long time. Only when I recalled what gains others were making out of my authority and reputation did I begin to ask for my share. Indeed if Duveen, abetted by his lawyer, had played fairly by me I should have at least double the capital I have now.[6]

In these complaints we see the germ of the critic's current malaise. However, the worlds of Berenson and Baudelaire differ from our own in very important respects. From the mid-nineteenth century to the early twentieth, the art market was still a primitive system run more or less on the honor system. Today the apparatus that supports the marketing of art often seems to have become an end in itself. It has spawned a variety of art professionals unimaginable in earlier days: artist's reps, corporate curators, private dealers, art advisers. Beside the noisy clanking of this machinery, the voice of the art critic seems scarcely audible, providing little more than an occasional burst of grease to keep the wheels moving. In the long run, this development has ominous implications. As John Perreault has warned, "Without independent art criticism the art system is in danger of replacing that which it grew up to support: good art.

5. Charles Baudelaire, "The Salon of 1859," reprinted in Lois Boe Hyslop and Francis E. Hyslop, Jr. eds., *Baudelaire as a Literary Critic* (Philadelphia: Pennsylvania State University Press, 1964), p. 181.
6. Bernard Berenson, quoted in Sophy Burnham, *The Art Crowd* (New York: David McKay Company, Inc., 1973), p. 86.

I have a sense that the art system – composed of dealers, collectors, investors, curators and artists – could continue without any good art at all."[7]

What, precisely, is it about the current situation that makes the pursuit of independent art criticism so difficult? One might, as some commentators have, point to the moral and personal failings of critics themselves, who have allowed themselves to be seduced by glamour or big money or who are simply too lazy to look and think hard about art. However, it is clear that the blame lies as much with the economic reality of art publishing. Aside from *Time,* the *New York Times,* and a few other large-circulation, general interest publications with well-paid in-house critics, the major forum for art criticism is the specialized art magazine. Despite the high costs of production including high-quality paper and lots of full-color reproductions, these publications have very low circulation rates. *Arts* reports a circulation of 28,000. *Artforum* reports 26,000, *Art in America* reports 56,000 and *ARTnews* 72,000. To put this in perspective, compare a circulation of 500,000 for *House and Garden,* 650,000 for *Esquire,* and over 3 million for *Newsweek.* Because the audience for specialized art magazines is by nature small, advertising becomes a vital source of support. This does not go cheap; a full-page color ad in *Artforum* goes for $3,050, and naturally advertisers must be persuaded somehow that the expenditure is worthwhile.

The four major magazines *Arts, Artforum, ARTnews,* and *Art in America* exhibit varying degrees of editorial independence from their advertisers. Occasional horror stories circulate about

7. Perreault, p. 82.

reviews "bought" with the purchase of an ad or critical articles squelched to appease a major advertiser. By and large, however, the art magazines attempt to avoid the appearance of capitulation. More subtle are the ways that their reliance on advertisers shapes their general editorial policies. Ellen Lubell, head of the American Section of the International Association of Art Critics, points out: "Art magazines are only interested in a limited scope of article. They get their advertising from museums and galleries and they don't venture editorially very far from their own market. So, unless you write about artists, art movements, or works on view, there are not a lot of outlets."

The other consequence of the art magazine's limited financial base is that the fees offered are absurd by the standard of magazine publishing. For example, 350-word reviews net $25 at *Arts* and *ARTnews;* 500-word reviews earn $75 at *Art in America* and *Artforum.* For feature articles, a writer who is not a big name gets $150 at *Arts.* Editors at the other glossy art magazines declined to report their fees, but an informal survey of writers suggests that the fees for features are in the $500 to $1,000 range.

Compare this with fees of $2,000 per article for *Smithsonian* and up to $3,000 for *Esquire.* Yet, these articles in art magazines may require months of research offering the writer an hourly rate well below the minimum wage. Other outlets offer even less. Features in the *Village Voice* are worth $200, and the *East Village Eye,* the publication that launched the East Village, pays nothing. The upshot is that, in Henry Geldzahler's words, "Unless you have money from home or write like three Anthony Trollopes, it's very difficult to make a living as an art critic."

So how do art critics survive? Obviously, most must supple-

ment their income with other work, and if they choose work connected with their interests, it is very likely to entail conflicts of interest. Working for a gallery or museum can raise sticky questions about one's primary allegiance. Teaching is unproblematic, but jobs are few and generally low-paying. Recently many critics have begun to supplement their incomes by writing catalog essays for commercial galleries. A critic can make two or three times as much (more if the critic has a big reputation) for a commercial catalog essay as for a comparable magazine article. Some critics are adamantly opposed to establishing this kind of connection with the commercial art world. "I think it's immoral to write for any commercial endeavor," Jeff Perrone says flatly. Carlo McCormick, who has himself written commercial essays, remarks, "A lot of really good writers do gun-for-hire work. I don't know if I really believe what they write. But the printed word is truth to a lot of people, and it's scary if you know what's really going on." On the other hand, John Perreault argues that if the critic is favorably inclined to the artist who is the subject of the essay, no credibility need be sacrificed. "It's understood that you won't say anything negative, but if you feel right about the artist, you can have a lot more freedom writing gallery catalogues than articles." And *New York Times* staff critic Michael Brenson says, "I get asked to do these things all the time and I always turn them down. But when I was living in Paris and was really poor, if someone had offered me $500 to write a catalogue essay on someone I liked, I would have agreed. It would have offered me a chance to show what I could do."

Other ethical dilemmas arise from the critic's unavoidable interactions with the world of commerce. Dealers and artists, anxious to secure a mention or a review, are not above offer-

ing inducements that a financially strapped critic might find nearly irresistible. What should a critic do if an artist or dealer offers to supplement the meager fee expected for an article or review the critic was planning to do anyway? What about gifts – artworks – offered by artists either before or after a review has been published? There is no established set of rules about such matters (just as there are no entrance requirements for critics), and as a result there is wide disagreement among critics as to which activities should or should not be proscribed. Some critics believe it is wrong to own a personal collection of art because of the danger that one may be swayed to support art to which one has committed oneself financially. Others argue that a critic chooses a profession out of love of art and shouldn't be penalized for that.

Another sticky area involves critics' relationships with collectors. Should a critic accept fees for advising collectors? One argument notes that critics who work as advisors are playing both ends against the middle, building artists' reputations through their writings and profiting from the success of that effort by cashing in on the sale of the artist's work. The counterargument holds that a critic has as much right as any expert to profit from his or her hard-won expertise and that, furthermore, this expertise can prevent collectors from making terrible mistakes and can help ensure that the best art of the day receives financial support.

There is no consensus in the critical community about these issues. Geldzahler, who in his long career has worn the hats of critic, curator, advisor, and collector, believes this is all to the good: "The world is better off without these rules. These kinds of rules presuppose a dreadful criminality on the part of the

critic." Clement Greenberg maintains that there are only two rules: "Never take money from a dealer and never write about relations or sexual partners."

In the absence of generally accepted guidelines for ethical conduct, critics are ultimately left to their consciences. Michael Brenson admits, "This job requires an unceasing vigilance which is tough to maintain. It takes a lot of energy to monitor yourself constantly, but you have to do it. If you lose the ability to say what you believe, you lose everything."

Criticism is not a field one wanders into under the impression that it's the place to make big bucks. Most critics get involved initially out of an interest in art, a love of ideas, or a desire to support developments that seem worthwhile.

The problems arise as the critic begins to be drawn into the art system. Jeff Perrone remarks:

The most important thing in the art world is socializing. That's where the possibilities for corruption are most apparent. Critics start going to openings with Champagne and waiters and catered dinners and for the first time they get to see a lot of rich people. . . . One thing leads to another. You would think that at a certain point people would stop and see what they're doing, but they don't. They see that dealers and artists and collectors are living well and they think, why can't I?

For critics who resist these temptations, virtue can take its toll. For one thing, one's writing can suffer. After all, how can a critic trying to make ends meet by writing like three Anthony Trollopes squeeze in time to reflect or even to keep up with shows unrelated to current projects? Psychologically, there are costs as well. Marjorie Welish has been a freelance art critic for 18 years and has been published in magazines ranging from *Partisan Review* to *House and Garden*. She remarks:

It is often said that each choice of profession has its price, but a more challenging way of saying it may be that every choice of profession entails specialization – not only specialization of intellect, but specialization of attitude. My material needs are small. I was drawn to art criticism, loving art and equipped by education to think about it, without needing to actually possess art to feel fulfilled. In time I became very expert at living on the minute income free-lance writing pays, but at some point I realized I had lost the capacity for desire; self-denial had indeed become effective. So, however art criticism may be construed as a profession for the privileged, it is a profession often accompanied by attitudes typically found among the hard-core unemployed.

As a result, as Ellen Lubell notes, "Around the ages of 35 to 40, there's a certain fallout rate. You realize there are other concerns and that you want more out of life. It's too frustrating to have achieved a certain level of prestige and still get peanuts for articles." Lubell herself, after writing regularly for years for *Art in America, Arts,* and the *SoHo News* and editing *Womanart,* has sharply curtailed her criticism and taken a full-time PR job.

To a certain extent, the economic difficulties of critics are not that different from those suffered by the vast numbers of artists struggling to juggle jobs and art without benefit of a nod from Mary Boone or a line of spinoff T shirts, shopping bags, and album covers. But while artists may dream of making it big someday, critics do not even have the comfort of grants to look forward to. In 1982, following a report prepared by critic and curator, John Beardsley, the NEA discontinued its critic's fellowship program. Hilton Kramer, who had attended a two-day seminar to evaluate the Beardsley report, published a report of the proceedings in *The New Criterion.* Kramer accused the critic jurors of cronyism and lack of standards, and charged, "A great many of [the grants] went as a matter of course to people who were politically opposed to

75

just about every policy of the U.S. government except the one that put money in their own pockets or the pockets of their friends and political associates."[8] Uncoincidentally, *The New Criterion*'s publisher, Samuel Lipman, was a member of the NEA council that decided to cancel the fellowship program.

However, as the preceding discussion suggests, there are real dangers in applying the neo-conservative gospel of government nonintervention in the arts to art criticism. Robert Hughes points out, "Art criticism can't survive in the open marketplace. If critics could make their living in a semi-graceful way, we wouldn't have puff pieces for Tony Shafrazi." In the crossfire of charges and countercharges directed by critics at each other and at the art world at large, there is a danger that the point of it all will be lost entirely. If art today is merely a more glamorous form of pork belly futures, then the critic's enterprise has indeed become obsolete. But if art still matters, then art criticism matters, because at bottom art criticism at its best has always been concerned to see that the worthy art of the time is recognized, valued and allowed to prosper. The failings of critics are many, and their mistakes could fill a large and amusing volume. Nevertheless, their presence serves as a reminder that art is not just another commodity and that something of the human spirit still escapes the homogenization of our time. If critics are discouraged today, they have every right to be. Still, they may take comfort in the fact that the one thing more depressing than the current situation would be an art world where their cranky voices are not heard at all.

8. Hilton Kramer, "Criticism Endowed, *The New Criterion*, November 1983, p. 1.

Artists versus the Market

Looming like a great irrefutable fact over any discussion of the contemporary art scene is the shadow of the art market, variously cast by different players in the game in the role of seducer, umpire, or jury. From the artist's-eye view, the market often appears, to use a medieval metaphor, like a kind of original sin contaminating what ought to be a disinterested activity with the foul taint of commerce. Consider some comments.

WALTER DARBY BANNARD: "Art is now a cultural obligation, and the art business has become the central focusing vehicle for social power."

JUDY RIFKA: "Whoever pays for art gets what they pay for. They can probably pay for history."

JOAN SEMMEL: "The market is like nature. It's merciless. It's like survival of the fittest."

It has become an axiom of the contemporary art world that the market now drives the art machine and that this phenomenon is a fairly recent development. But even in the nineteenth century, Charles Baudelaire, in his "Salon of 1869," was bemoaning the ties between art and money in terms that sound remarkably contemporary:

Despite his lack of merit, the artist is today, and for many years has been nothing but a *spoiled child*. How many honors, how much money has been showered upon men without soul or education . . . while good poets and vigorous historians make their livings with extreme difficulty, the besotted business-man pays magnificently for the indecent little fooleries of the "spoiled child."[1]

Nor are the speculative mentality and the roller-coaster career inventions of the 1980s. In his book *How New York Stole the Idea of Modern Art* (Chicago, 1983), Serge Guilbaut recounts how the rise of abstract expressionism was accompanied by the obliteration of the careers of a group of previously well-established cubist-based painters, some of whom had to face the indignity of seeing their work dumped in a half-price sale at Gimbels department store.

Within more recent memory, the unexpectedly high prices generated by the Scull sale of 1972 marked a new awareness of the potential of investment in contemporary art. "Things changed overnight when the Sculls sold their pop collection to the Germans," Neil Jenney recalls. "You could feel it a month later." Collector Elaine Dannheisser confirms this impression. "We knew something was happening the night of the Scull sale," she says. "All of a sudden there were all these new players."

Nevertheless, for many artists, particularly those who came of age in the early 1960s, or for that matter in the 1970s, both periods when the market was relatively dormant, there remains a strong sense that the rules of the game have changed. "My generation's mythology involved the romance of being true to oneself," says Joan Semmel. "You were supposed to starve,

1. Charles Baudelaire, "The Salon of 1859," reprinted in Lois Boe Hylsop and Francis E. Hyslop, Jr., eds., *Baudelaire as a Literary Critic* (Philadelphia: Pennsylvania State University Press, 1964), p. 181.

because success meant you weren't really honest, and then be rediscovered by the next generation. . . . To be an artist meant to choose a different life-style – to live minimally, with cheap rent and minimal needs and somehow survive. Today no one can afford that romance."

One reason for the change is painfully evident to anyone who leafs through the real estate section of the *New York Times* – SoHo lofts renting for $6,000 a month, and even in Brooklyn, going rates of $1,200 on up. James Rosenquist reports that when he moved from Minneapolis to New York in 1966, it was actually cheaper to live in the larger metropolis. "My grocery bill was $26 to $30 a week; my rent was $10 a week for five rooms. On a salary of $110 a week I could save $50 or $60 a week. That bought a lot of paint and canvas." Today, the costs of being an artist in New York have increased exponentially. Bill Conlon estimates that "taking into account rent, assistants, materials and shipping, to run a modest studio in the city costs $26,000 a year. That means you have to make $60,000. And that's modest."

Such financial realities may explain the oft-lamented market savvy of younger artists. "When I first came to New York in 1980, I couldn't get a teaching job, the New York State grant program had been curtailed, and the budgets of the alternative spaces were on the wane," Peter Halley says. "Exhibiting seemed to be the only way open to making a living as an artist." He adds, "A lot of people say younger artists embrace the market. I haven't seen that to be the case. However, the attitude of disdain and hostility toward the mechanism by which the art support system in the modern era functions began to seem ludicrous."

Ashley Bickerton echoes this sentiment: "If I'd come into my own in 1968, I'd have been only too happy to drive a tractor

across the desert or burn the hair off my chest with a lighter. But today we're responding to a different episteme."

Another reason for the change in atmosphere is the sheer amount of money now lavished on art. The record prices at recent auctions have made headlines. And in the first-sale market, the buying boom that began with the neo-expressionists shows no sign of letting up. Pundits predicted that the October 1987 stock market crash would reduce or at least stabilize the demand for art, but instead it seems to have had the opposite effect. Dealer Curt Marcus reports, "Business has been unbelievable for galleries and auction houses. Whenever the stock market goes down, people put money into luxury items and that, of course, includes art." Elaine Dannheisser adds, "I don't think even a recession would affect the market at this point. There's just so much money out there. It's getting more and more difficult to get the work you want."

As demand heats up, so do accusations that the market is being driven by speculators. "Speculation always existed, but the situation has deteriorated in the last year," Sandro Chia maintains. "The art system is simple. There are a few magazines, a few galleries that count. To gain control of this relatively simple system is not complicated."

And indeed, as many younger artists have discovered, inclusion in a key group show or a nod of approval from a megacollector may be all that is needed to turn a lukewarm career into a sizzling one. Barry X. Ball describes the phenomenon:

The thing that precipitated the gold rush was my inclusion in a show called *Geometry Now* that happened to coincide with the emergence of the Neo-Geo thing. I had never heard of Neo-Geo. I think what happened is that lots of people came to see an in-the-flesh Levine or Halley and discovered my work as well. Within a month I sold every-

thing I'd ever made. The pressure to produce work has been at least as intense ever since.

Ball reflects that the collectors' insatiable hunger for "hot" work can affect the artist's working process. "This system doesn't work with someone who produces a small amount of work. There's a constant pressure to produce and turn it out fast. I've found that it changes the way I work. I'm not allowed to make mistakes anymore. I can't have old work around to look at. I don't deliberate as much." He notes that high demand has also been a boon to the fabrication industry as artists hand over more and more of the execution of their work to others, leading to a situation in which "artists often know less about their work physically than others do."

The constant quest for new faces – what Ball refers to as the "thrill of the chase" – has also changed the way collectors go about putting collections together. "I've seen collectors roll over their collection two or three times or dump everything on the market," Gary Stephen says. Consultant Estelle Schwartz argues that a limited turnover is very normal. "I don't think it's unhealthy if a collector on occasion sells something and acquires something else, because there is another collector out there who is delighted to buy it, and an artist should always be in a collection where he's wanted. Some artists and dealers terrorize collectors if they think of selling." However, she adds, "I have no problem with selling if it's not done to 'dip' or speculate. One knows whether one is 'dipping' or not."

For the artist, the highly volatile market is full of potential hazards. Matt Mullican notes, "The higher the market goes, the more precarious the situation of the artist. If I'm making money, I just put it in the bank because you never know what

will happen. And I hesitate to put too much work in any one collection."

There are psychological costs as well for artists subjected to the whims of the market. Those in the limelight find that the pressure to exceed themselves never lets up. "When I first started showing, to sell one piece was a big deal," says Chia. "Now if you don't sell everything the day after the opening, you're considered a failure."

Artists outside the limelight are equally aware of the market's capriciousness. Agnes Denes quotes a bit of common wisdom, "If you don't make it when you are very young, you won't make it until you are very old." In between these two poles lies a vast no-man's-land known as the "midcareer" – that awkward time when an artist who has achieved a degree of recognition is no longer the latest wunderkind. Phyllis Bramson describes this difficult period: "Midcareer feels like a hole. You have this career but you're hovering. You've accomplished a certain amount, but the hill is still so high and you're not sure you'll ever get there." She adds, "If you pause, you're gone. You have to win the game every time."

Semmel argues that the art system's brutal selection process serves a hidden purpose:

The market is structured in such a way that it can sustain only about five artists from each stylistic group. Once they have been anointed and their work has sold for a certain price, it is in the self-interest of all involved to maintain that investment. But what comes to the top is the result of a combination of factors. The goods have to be there, of course, but there are many others who also have them. So, we've erected this myth of the scarcity of genius, which is demanded by the market since, if there were many geniuses, prices would have to come down.

Related to this way of thinking is the notion that art must always increase in value. As Bramson points out, this creates a dilemma for artists who move in and out of the spotlight:

A midcareer artist has reached a certain level and suddenly dealers are saying, you're not young, I can't start you out, you're in a difficult price range. There's this rule that artists can't lower their prices, but if you can't, how do you get things going again? Instead of saying, let the work find a home and let the artist continue to work, the system encourages the artist to start amassing a whole body of work that's really valuable. Things are almost set up so that the work won't sell.

Dealer Irving Blum argues that lowering prices would ultimately be counterproductive for both dealer and artist. "You don't want to betray your best customers," he says. "If you get to a certain level and aren't selling, perhaps it's because prices have become too heated. Rather than lower prices, it's better to maintain the quality and wait. If people think the prices will go down, they won't buy."

One of the paradoxes of the current art boom is that it hasn't really made most artists' lives any more financially secure. In order to cope with the uncertainties of their situation, artists have evolved a variety of survival techniques. Denes, without a gallery for many years, sells work directly to museums and collectors. Jenney works through many galleries without committing himself exclusively to any one. "You don't need a dealer, you need exposure," he says. "I think the strategy for a young artist is to be in as many group shows as possible and to work with as many dealers as possible." Many artists teach. Robert Colescott remarks, "I've always operated with a teaching job as my base. It's a negative push to hang in there and not just fall into the academic thing." However, he acknowledges

that there are liabilities, especially if the teaching job takes one far from the center of activity. "In some ways, it's easier to live outside New York. On the surface the economics aren't as aggravated, but when you get down to it, this is a very expensive and unstable profession. If you live elsewhere, you have high travel expenses and phone bills. It affects you wherever you are." He adds, "I tell young artists, 'Head for the big city. Go there, learn, stay long enough to get started.' But it's like telling them to go up Mount Olympus on foot."

Another option, for those whose work is appropriate, is to focus on Europe, where memories are longer and money for noncommercial projects is more available. Dan Graham, whose temporary installations are generally financed by the gallery or museum that exhibits them, notes, "I'm an example of someone who strangely survives by being better known in Europe." He explains, "I've shown in a lot of places in Europe, and while no one made money, it didn't much matter. The rents on galleries are much less, and there is a larger tradition of patronage and collecting. In the U.S., the pressures of failure and success are much greater."

Dennis Adams, whose public-art pieces have recently found a very receptive audience in Europe, echoes this assessment. "In America we've broken with the historical connotation of the collector as someone who puts together a related body of work based on a personal vision. That remains in Europe." Because in Europe the market is less volatile and expectations for sales are more modest – as Adams notes, "In America there are a handful of collectors and many buyers; in Europe there are also just a handful of collectors, but there are no buyers" – he finds that "European dealers are absolutely more receptive to concepts. They're willing to fund projects where the monetary

outcome may not be clear. You sense that this is a long-term investment and maybe a life commitment. In New York if you do something with a dealer it feels like a one-night stand."

As the nineties loom, there is a feeling that the last decade's romance with commerce may be going the way of the Reagan administration. "We may be leaving the time when sales are the sign of a successful show," Marcus says. "I have this feeling that the fast money buying fast art may be on its way out." Ashley Bickerton reflects, "Things may be settling. Now the speculative impulse seems to be playing itself out on the resale market." As for his own work, which has been closely tied conceptually to the notion of art as product, he says, "I'm breaking clear of that issue and pulling away from the idea of commodity art. I think others are too."

Meanwhile, Thomas Nozkowski, who expresses regret that the alternative movements of the seventies never lived up to expectations, argues, "The sheer weight of the numbers of artists may create new institutions. Everything could change instantaneously with the smallest shift of consciousness on the part of artists, dealers, and collectors." However, he admits, "The promise of $80,000 for a painting is seductive to us. As Julius Caesar said, 'The fault lies not in the stars but in ourselves.' "

Art Impresarios

THE CONJURING OF THE
CRITIC–CURATOR

Of the reverberations set off by the art boom of the eighties, none was more disruptive than the one that resounded through the world of the American art critic. Once among the most respected and influential members of the art world, many critics felt themselves reduced to the role of poor relations, permitted to join the celebrations of this bountiful time only through the good will of the now all-powerful dealers and collectors. Faced with a sense of impending irrelevance, critics responded in a variety of ways. Some pulled back, professing a distaste for the collapse of the aesthetic into the commercial. Others experimented with expanded definitions of the critic's role. And perhaps most interesting (and, in the view of some observers, most distressing), some pioneered new hybrid forms of activity that blurred the boundaries between criticism, business, and promotion.

The current confusion among American art critics has its roots in the art establishment's still unresolved ambivalence toward the legacy of Clement Greenberg. In the forties and early fifties, Greenberg almost singlehandedly invented not only the American profession of art criticism but, some have argued, American modernism itself. A passionate advocate of a

small and initially obscure group of artists, he created a philosophical context for their work that placed them at the forefront of the evolution of modern art. More problematically, he also worked to ensure their economic and institutional success in the marketplace and the museum world. Eventually his activities on their behalf led to charges of manipulation not only of dealers and curators but even, through his influence on their aesthetic decisions, of the artists themselves.

Although he was once the undisputed lord of the New York art world, Greenberg's influence began to slip and then to crumble completely in the late fifties and early sixties as his increasingly doctrinaire version of art history began to clash with the emergence of unassimilable developments like the rise of minimalism, pop, and conceptual art. In time the label "Greenbergism" came to be as despised as it had once been celebrated, identified with megalomania, authoritarianism, critical hubris, and a wrong-headed desire to direct the course of history.

In a sense, the most pervasive model for criticism as practiced in America today was formed in reaction to the excesses of Greenbergism. This model stresses distance from the crass world of business and promotion, an intellectual and economic independence, and at times an almost journalistic objectivity. Although critics may press the case for certain artists, tendencies, or philosophies, they are not expected to realize any personal financial gain from their advocacy and they are expected to be very wary about the deployment of their expertise in the service of dealers, collectors, or artists. Not surprisingly, questions of ethics and morality have often been at the forefront of the critical debate. What is the proper relationship between critics and dealers, curators, and artists? Is it proper to accept gifts from artists? To write about artists who are friends or

whose work you own? To accept money from dealers for any reason, even for the writing of a catalog essay for a commercial gallery show?

The eighties boom placed great strains on this genteel model as it became clear that these unspoken ethical guidelines made it virtually impossible for critics to benefit from the shower of prosperity that was raining down upon everyone else. Once joined to the larger art world by a sense of common struggle, critics suddenly discovered that they were still taking the subway while everyone else had graduated to limousines. Given the extremely social nature of the art world, the disparity between the life-styles of the still starving critic and those of the successful artist or dealer became impossible to ignore. At the same time, the heightened economic stakes gave art criticism a new and often unwelcome kind of significance.

Kim Levin, who writes for the *Village Voice* and is currently the head of the American Section of the International Association of Art Critics, recounts her awakening to this new situation:

In the eighties, in spite of the fact that critics had become marginalized in the whole scheme of the art world, it also became clear that if you wrote something, it might have monetary influence. The first time I realized this actually seemed kind of sweet. I wrote a little piece about David Wojnarowicz in the *Village Voice* in connection with his second show in the East Village. Later I ran into his dealer, who said to me, "You've changed our lives." Because I wrote this little thing, a collector called him up and came downtown in his limousine and bought $4,000 worth of work. So the dealer could quit his temporary job and move into an apartment and the artist could quit his temporary job and devote himself full time to his work. [However, she adds,] Although it started out very nicely, when you think of that kind of thing happening on a larger level, the implications are more disturbing. And it can work the other way. I wrote something about some work in which there were questions of authenticity and later someone said to

me, "You probably made them lose five million dollars. Aren't you afraid they'll come after you?"

This potential to influence sales has created a climate in which critics are often viewed by artists, dealers, and collectors less as autonomous commentators than as attendants in the process of commercial validation. Free-lance critic Dan Cameron reports that he is beginning to hear numerous cases of verbal or physical assaults on critics by artists whom they have criticized in print. He remarks:

Because critics are outsiders to the business machinery, we don't get a cut from anything anyone sells to anyone at any time. Already twice disadvantaged, it's very upsetting to be put upon in this new way. In every case, the motif seems to be the importance of getting the critic under control, lassoing in this errant member of the tribe. I think this new attitude is due to the market entirely. Back in the seventies there was this illusion that we were all slugging through this together. Now the only ones slugging through it are the critics and everyone else is out at the Hamptons.

Thus, for critics, the art world of the eighties was a very peculiar place. On the one hand, they felt their influence wane and their independence become threatened as the balance of power shifted in favor of the money people. On the other, the burgeoning interest in art created new audiences and hence new outlets for their work. New art magazines proliferated in the eighties, existing publications grew in size, and popular publications took an interest in advanced art. Jeffrey Deitch, independent art advisor and sometime art critic, points out, "Art has become part of the international fashion communications industry. This audience wants to know what Valentino is doing, they want a story about Stephen Spielberg, and they want a story about David Salle."

Thus, where critics oriented in more traditional ways found obstructions and difficulties, others discovered opportunities. The new respectability of money in the eighties facilitated the emergence of hybrid roles that would have been inconceivable in the more straightlaced seventies. The artist-dealers of the East Village are one example; critics who also operate as independent curators are another. These latter work in various ways. Some, like Dan Cameron, see curating as an extension of their critical activity. Currently confining his curatorial activities primarily to exhibitions in Europe and primarily to noncommercial venues (one of his major efforts in this area was his exhibition *Art and Its Double: A New York Perspective,* which appeared in Barcelona in 1986), Cameron explains his intentions thus: "Critics today are probably as empowered or unempowered as they want to be. As a writer I've chosen to empower myself by also curating, and it is clear to me that if I didn't organize exhibitions, I would not feel I was making as complete a statement of my ideas as I could." He adds, "When I am operating as a critic, a lot of the time I feel that I am simply reacting, whereas curating an exhibition seems primary."

In his curatorial mode, Cameron generally works by invitation and for a flat fee. By contrast, a more controversial path has been taken by critic-curators who package shows themselves and present them in commercial spaces for a percentage of sales. Differentiating themselves from old-fashioned dealers both by their lack of a relatively permanent stable of artists and by their theoretical aspirations, these critic-curators often appear to view the artworks they have gathered together as mere raw materials to be shaped to their own vision. At the same time, however, their shows exist as well in the commercial world, and they can point to a number of now well-known and

financially successful artists who received their first exposure and support from their association with an independent curator.

When dealing and criticism blur to this extent, it seems that perhaps a new category has been created. Critic Thomas McEvilley, writing in *Artforum* (May 1988, p. 11), has dubbed this new phenomenon "simulationist criticism." He remarks, "So much a partisan effort is this 'simulationist criticism' that so far, anyway, most of it comes either from the artists themselves or from those who curate the work. It is not critical in the usual senses, then, but promotional, aimed at establishing a supposedly new artistic position." He adds, "The simulationist critics simply declare the art new, and then surround it with a rhetoric of newness. Advertising proceeds toward its ends in much the same way."

Perhaps the foremost practitioners of this new species of criticism are the curatorial team of Tricia Collins and Richard Milazzo. The pair are known both for their perceptive eye – they were among the very first to support such artists as Ross Bleckner, Peter Halley and Jeff Koons – and for the almost impenetrable prose that appears in the catalog essays that accompany their shows and that has been described as sounding as if it were badly translated from the German. This opacity is intentional and seems at times an art world in-joke – a parody of the most convoluted and pretentious sort of academic prose. Agreeing to be interviewed for this article on the condition that all statements be attributed to the corporate identity Collins & Milazzo, they defended themselves against charges that their work amounts to advertising. They argue, "We really don't write for any magazine, and our prose is somewhat tortured. It has nothing to do with selling art. It functions more on a literary level." Pressed, they admit that these charges have less to do

with their writing per se than with their attitude toward the business of art:

> The criticism is really about exceeding the boundaries in other ways. . . . There are a lot of unspoken rules about art criticism in the art world. There is an attitude which seems to come out of the academic business of publish or perish, that critics should be paid a pittance for writing. But for someone not involved in academia, that makes it almost impossible to earn a living.

And, they charge, those who brandish these rules against them are themselves implicated in the market in other ways. "There is so much hypocrisy. Critics who take a holier than thou attitude toward us will turn around and undertake to write catalogues for private collectors. That has an absolute connection to the value of the work, yet they eschew any public responsibility."

The unashamed mixture of theoretical concern, advocacy, and business acumen that marks the thinking of Collins and Milazzo resurfaces in the many-faceted career of Jeffrey Deitch. Like them, he is a figure who only could have emerged in the eighties. An art historian with an MBA from Harvard who has operated as a critic, editor, assistant gallery director, museum curator, and in-house art advisor to Citibank and now runs his own business as an independent consultant, Deitch argues that it is possible to move between the worlds of criticism and business with integrity as long as there is no subterfuge about the nature of one's various roles. Although he first surfaced in the art world as a critic, he explains, "I like the business of art, and some time ago I decided I did not want a life of low-level hustling for catalog essays. . . . I'm very interested in the idea of the kind of dealer who also makes a scholarly contribution.

You can use the commercial system, not only to make a living, but to put forward the ideas you have." In his case this means occasional articles for magazines like *Arts, Art in America,* and *Artscribe,* as well as self-published books and catalogs. He notes that one of his ambitions is to publish a collection of his writings about contemporary art.

Deitch believes that conflicts of interest arise when the business link is more disguised. He maintains:

> The sort of thing everyone criticizes is more likely to involve someone who writes a catalog essay for $5,000 for an artist whose work they never saw before in a situation in which they are lending their famous name to allow everyone else to make more money. If I believe in an artist, I would much rather buy his or her work, look at it for a while, and, if I feel I have something to say, write something about it. So instead of making $5000, I have a body of work and I'll make a million dollars.

He adds, "If you believe in an artist there's nothing wrong with putting your money behind it and giving serious advice to friends to put their money behind it. . . . The important thing is to have some integrity about what you believe in and to make it clear to people what that is."

For more traditional types, this type of talk is evidence of the decadence of the times and a violation of the notion of independent criticism. Critic Peter Schjeldahl says flatly, "There's a tremendous amount of corruption. I don't think that a critic who curates or who consults with a collector is functioning as a critic at all. The secondary role swallows the first. Criticism is either entirely independent or it isn't criticism at all." In a similar vein, Kim Levin suggests that the days when a critic could comfortably act as an advocate and promoter are over, obliterated by the distorting influence of the money culture:

Back when Greenberg was in his heyday, there was no art market to speak of and most critics operated by choosing a group of artists and promoting them to create a movement. While some people still operate that way, it seems to me that it's a thing that can't be done anymore because it makes it impossible to distinguish the critic from the public relations person. [She adds,] I almost feel that the role of the critic now is to be adversarial – to point out the clay feet of whatever is happening that everyone is talking about.

At the crux of this controversy is what may be a particularly American notion of ethics and morality. Levin notes that she once reduced a French colleague to incredulous laughter when she described a *Village Voice* rule that a critic may not write about a friend without divulging that relationship in the article. Schjeldahl remarks, "There is a tremendous cynicism in Europe that I am continually irritated by. People simply don't believe that you are not bought by galleries. On the other hand, they think it's really childish that you wouldn't accept payment from a gallery for an article published in a magazine, which to me is the absolutely classic case of corruption."

Is this simply, as Levin's French friend charged, an example of American puritanism? Is the discomfort felt by more traditional American critics toward the new types of activity being explored by Deitch or Collins & Milazzo just a manifestation of what Deitch terms a "narrow professionalism" that precludes the possibility of a broad strategy encompassing all the institutions of power in the art world? Is the legacy of Greenberg, with its marriage of theoretical rigor and entrepreneurial enthusiasm, an example to be emulated or shunned?

In the end, despite the attractiveness of the rhetoric of the new entrepreneurs, real questions remain as to whether the union of art and money in the eighties was in fact all that

beneficial for either art or criticism. Already there is evidence in the resale market that the work of many of the so-called giants of the eighties may not be able to sustain the position in art history to which hype and money artificially elevated it. To what extent were critics – were we all – blinded by the veneer of gilt that went for gold?

In the United States, the money culture that characterized the eighties is already crumbling, thanks to the strains of various financial scandals, bad investments, and overextended credit. The art boom was just another part of that shaky edifice, under-written, as Schjeldahl points out, by what will ultimately turn out, in the wake of the savings and loan bailout, to be the American taxpayer. The art world of the nineties promises to be a far more sober place than its glitzy predecessor. After the dust settles, it is quite possible that the question of whether artists and critics should remain stalwartly pure or reap the benefits of a burgeoning market may once again become an academic one.

Body Work

SEXUALITY AND TRANSGRESSION

David Salle: Impersonal Effects

The controversies surrounding David Salle's work focus on a number of key issues with wide-ranging implications. Is, for instance, the postmodern strategy of pastiche and appropriation an automatic prescription for sterility, or does the deconstruction of cherished assumptions open art up to new avenues of investigation? To take the question a bit further, does an ostensible refusal to embrace legible meaning ultimately become a moral issue? On a more controversial note, can and should decisively sexual subject matter be rendered in a manner that is free not only of judgment but even of any implied value system? Meanwhile, the vulnerably posed female nudes that pervade Salle's paintings raise a secondary set of questions that exacerbate the rifts within contemporary feminism: Does the reproduction of imagery that objectifies women serve to expose, or does it rather exploit, female subjugation within a patriarchal society? Is deconstruction of matter without some form of reconstruction enough? Is the presentation of voyeuristic sexual imagery in a "high art" context purely provocative, or might there be socially redeeming side effects in its challenge to established mores?

The Salle retrospective, which completed its run in Chicago in January 1988, offered the opportunity to elevate the various claims of the artist's supporters and detractors. Seen in large numbers, Salle's paintings make clear the shortcomings of much of the critical analysis they have till now elicited. There have been, for example, numerous attempts to deny any larger significance to the images that seem to float unanchored over the surface of his canvases. In this view, Salle is the ultimate Baudrillardian, reveling in the nonnarrative play of detached signifiers. A related position presents Salle as a neutral conduit for the contradictory and ultimately empty messages of popular culture. In Thomas Lawson's formulation, "Salle records a world so stupefied by the narcotic of its own delusionary gaze that it fails to understand that it has nothing actual in its grasp. Amid seeming abundance, there is no real choice, only a choice of phantasms."[1]

Yet both of these explanations, in their efforts to ward off allegorical readings of Salle's work, scant the clear evidence of selection and purposive arrangement. Meanwhile, those commentators who have focused on content have tended to concentrate on the salacious imagery, which, up until two or three years ago, had been growing more explicit with each show. The parade of nude and often headless female bodies displaying their genitals in poses of sexual submission has sparked a heated feminist debate about whether these images serve to deconstruct our culture's objectification of women or reinforce a pervasive mysogeny. However, by focusing obsessively on one category of Salle's imagery, these critical treatments seem to suggest that the choice

1. Thomas Lawson, "Toward Another Laocoon or, The Snake Pit," *Artforum,* March 1986, p. 103.

of other recurring images – *National Geographic*-style tableaus of tribal scenes, cultural icons (Abraham Lincoln, Santa Claus, Donald Duck), retro furniture, "primitive" sculptures – are as arbitrary as the Baudrillardian critics maintain.

In a 1987 book of interviews with Salle conducted by Peter Schjeldahl, the artist suggests another way to look at his work. He tells Schjeldahl, "I think that there is an idea about the body being the location of human inquiry that one finds in my work, that makes it somehow resonant with much earlier kinds of painting." A bit later he adds, "The contemporary consciousness holds that 'I own my body' and my painting's interest in 'body' goes against this liberal hubris."[2]

In choosing the body as his "location of human inquiry," Salle joins a number of other prominent contemporary artists, but the differences in their approaches are instructive. As Robert Storr recently pointed out, Francesco Clemente's obsession with bodily functions, polymorphous sexuality, and organic processes reveals a "mystical fascination with the body as a 'communicating vessel' "; Storr adds that, for the Italian artist, "sensation is intelligence."[3] Although there are also orifices aplenty in Salle's work, the bodies he represents lack the fluid mutability of Clemente's; they seem more like artificially preserved specimens than active participants in the flow of life. If they are vessels of anything, it may be only their own emptiness, a vacuity echoed, in many of the recent paintings, by the deployment of eccentrically shaped pots and vases. Two other artists whose work has also flirted with the conventions of quasi-pornographic imagery

2. Peter Schjeldahl, *Salle* (New York: Elizabeth Avedon Editions, Vintage Books), 1987, pp. 72–73.
3. Robert Storr, "Realm of the Senses," *Art in America,* November 1987, p. 139.

are Eric Fischl and Cindy Sherman. However, they have received considerably less flak than Salle has, probably because they have embedded their sexual references within a more immediately familiar – thus "acceptable" – social field. Fischl, for instance, presents sexuality, especially adolescent sexual awakening, as the snake in the suburban garden. Sex is the repressed but potent disrupter of picture-perfect family relations. Sherman, in some of her recent series, has appropriated semi-"sluttish" or sexually vulnerable poses to create haunting images of the self robbed of its identity beneath the objectifying gaze of the viewer. In other recent works, she has reversed this relationship, as her harridans and grotesques aggressively challenge the observer's complacent mastery. Thus she explores the incessant dance between selfhood and otherness, transcendence and objecthood, that Sartre described as the essence of human relations.

Both Fischl and Sherman implicate the viewer as voyeur, drawing him or her into an uncomfortable and problematic relationship with the events represented within the picture. By contrast, Salle insists that his nudes are not intended as invitations to voyeurism:

The point about the poses in my work is that they are the body in extremes – often seen from strange points of view and spatial organization. It has more to do with the abstract choreography and angles of vision than with pornographic narrative. They are not voyeuristic in the sense that Eric Fischl's depictions of intimate family scenes are voyeuristic, because they're not candid – i.e., they're specifically posed in order to be seen that way.[4]

And indeed, voyeurism demands the existence of an alternate world to which the voyeur seeks secret, ocular access. Salle

4. Schjeldahl, p. 66.

offers no such world[5] – on this point the Baudrillardians are correct – and hence the body in Salle's work offers no privileged access to a network of imagined relationships, as it does in the work of Clemente, Fischl, and Sherman.

It is on this point that any characterization of Salle's work as "pornographic" ultimately stands or falls. Indeed, it seems somewhat strange, given the work's determinedly nonnarrative – if not in fact antinarrative – manner, that the issue of pornography or of pornographic representation in Salle's painting comes up with such persistence. Pornography requires, above all, that the action, presumed or explicit, draw in the viewer – whether as protagonist, antagonist, or simple fantasist. Salle generally subverts this possibility.

Thomas McEvilley has suggested that the "problem" of pornography is a result of Western culture's tendency to split the representation of the body into a "dual track" system. In what we think of as high art, nudity is imagined to exalt the spirit and draw the mind to higher things, whereas pornography offers a nudity whose only purpose is to induce vicarious sexual excitement. Describing the mechanisms of the latter genre, McEvilley observes:

In this underworld genre, either a lone participant acts out a fantasy for the viewer (for example, in the centerfold image) or two or more participants are directed and photographed through formal modes (for example, through a decapitating camera style that emphasizes gender details and deemphasizes the face) in which personality and responsibil-

5. Salle quoted in Rosetta Brooks, "From the Night of Consumerism to the Dawn of Simulation," *Artforum,* February 1985, p. 77: "If world is in painting and you are imposing other worlds on top of world in painting, that is perhaps Surrealism. But if there is literally no world in the painting, but there are just 'worlds' and you are superimposing that in a way that becomes the painting, that's conceptually different. My work is about 'no world' in painting."

ity are denied. To a degree, this denial of relationship, which is in direct opposition to the ethics of art, is the essence of mass market pornography.[6]

Salle occasionally (and obviously in full consciousness) incorporates these mechanisms into his paintings and consequently seems to offer a textbook demonstration of high-art pornography. The mind-body split McEvilley describes manifests itself in Salle's evocation of a reality that apparently devalues consciousness. The viewer is frequently invited, indeed coaxed, to see bodies as things. In Salle's paintings, cropped, often headless beings seem unrelated to the rest of the world except by their passive offering of flesh. With something like the same regularity, however, things are depicted as bodies. Salle's fascination with retro styles and sixties furniture in both his art and his personal life has been much commented on. The Eames chairs, wing chairs, and kidney-shaped coffee tables in his paintings – as well as the lurid colors – have their real-life counterparts in the decor of his own living space. Salle's attraction to a design period in which inanimate objects assumed undulating biomorphic shapes makes perfect sense when one considers the way in which all the elements in his paintings become sexualized. A real umbrella hanging across the heavy upraised thigh of a partial female body in *Melancholy,* 1983, is undeniably phallic, and a pair of Eames chairs offer an unexpectedly strong image of female accessibility when, in *Brother Animal* (also 1983), they project from a canvas painted with the representation of a young girl buttoning (or unbuttoning) her blouse under a man's watchful gaze.

The same sexualization occurs in Salle's references to other

6. Thomas McEvilley, "Who Told Thee That Thou Was't Naked," *Artforum,* February 1987, p. 106.

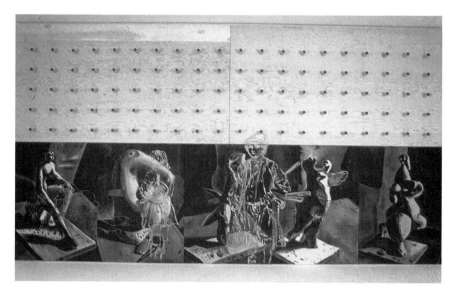

David Salle, *My Head*

art. The plywood panel that tops *My Head* (1984) is set with blue-tipped pegs arranged in regular rows. The reference to minimalism is clear, but one can just as easily read these regular protrusions as a series of erect penises. The left panel of *The Bigger Credenza* (1986) is one of the most open of Salle's compositions, containing four simple green biomorphic shapes, the most prominent resembling a doughnut-topped exclamation point. This homage to biomorphic abstraction becomes an image of penetration when paired with the adjoining image of a nude woman lying passive and spread-legged on an operating table.

However, despite the fact that Salle presents a world in which every element is sexualized, his paintings are not actually erotic in effect. In fact, any erotic charge is neutralized by his standard distancing devices – the grisaille, the painted overdrawing he has

David Salle, *The Bigger Credenza*

favored until very recently, the unsettling juxtaposition of imagery that is his primary organizational device – but even more, it is contravened by the deep structure of the body-to-self relationship in his work. In real pornography, as Susan Sontag has noted, mind, spirit, and will are subsumed by the body as it surrenders unconditionally to the law of physical desire. Thus, she points out, the real subject of pornography is not sex but the threat of death through annihilation of the self. The lure of pornography is that it offers a new kind of knowledge, available only on the far side of self-consciousness.[7]

In Salle's work we are presented with a self that is incapable of that kind of voluntary annihilation because spirit, rather than

7. Susan Sontag, "The Pornographic Imagination," reprinted as the introduction to Georges Bataille, *Story of the Eye* (London: Penguin Books, 1982), p. 115.

being subsumed under bodily need, is made to appear altogether absent. It is not death, as so many commentators have proposed, but the state of having never been alive that haunts Salle's paintings. As a result, his works are full of images and devices that speak of disconnection. Salle's most famous signature device (after the splayed nudes) is, of course, the layering and juxtaposition of images that employ incompatible modes of representation; Salle overtly – and with some degree of demonic humor – challenges us to read the images thus represented as inhabitants of the same world. In the resulting clash, and our acceptance or nonacceptance of it, lies his largest subject. For instance, *The Cold Child (For George Trow)* includes a frontal view of a woman arching her back so that her open legs form an inviting entryway. She is softly modeled as a three-dimensional form. Painted over her in outline is a drawing of a group of male cafe diners. Standing over the diners, a waiter holds aloft a tray of drinks arranged so that it directly coincides with the woman's vagina. One reading of the image is clear – that the woman is being served up or is offering herself up on a platter – but at the same time the implied oral gratification, whatever its degree of mutuality, will never be achieved because the two worlds can never really intersect. There are numerous other examples in Salle's work of such frustrated coupling, leading finally to the conclusion that sex, in Salle's world, is forever incomplete – like the endlessly deferred activity of Duchamp's ineffectual bachelors.

A similar device is the grisaille rendering of the female bodies in his work. These blandly modeled monochrome images saturated with a translucent field of color have the quality of faded black-and-white snapshots. Rarely, if ever, does a woman in Salle's paintings get the full color treatment. (Here Salle differs

greatly from Rosenquist, with whom he is often compared and who presents his red-lipped beauties with all the shorthand sensual immediacy his billboard training allows.) In Salle's paintings, the objects and images that come zooming to the fore are more likely to be cultural icons (the Santa head in *Wild Locusts Ride* (1986) or the Donald Duck in *B.A.M.F.V.* (1983) or inanimate objects, whether painted (the numerous full-color vases in recent paintings) or appended in actuality to the painting's surface (Salle seems to favor furniture particularly). The women, by contrast, seem ultimately untouchable, their apparent availability contradicted by their visual removal.

This distancing, in one way or another, affects even the women in Salle's work who are endowed with the certifiable individuality of portraiture. Dancer and friend Karole Armitage, for example, whose waiflike countenance appears in many recent paintings, is also consistently rendered in the grisaille manner, with the result that she, as much as some of the anonymous female nudes, seems to be seen through a filtering apparatus that may be meant to be as much cultural as personal. Thus, for instance, in *Lost Barn Process* (1985), an orange-tinted image of Armitage, cropped at shoulder and head, is centered in a beige ground that functions like a picture frame around a photo portrait. Meanwhile, by far the most vivid images in the work are a pair of full-color copies of severed male heads by Gericault. One such head tips back, wide-eyed and open-mouthed, on a piece of fabric – in its rigor mortis far more conventionally "vital" in rendering than the apparently preoccupied Armitage.

Ultimately, the studied dispassion and disruption of connection in Salle's work contradicts the assertions that his work is pornographic. Rather, his paintings seem to represent the antithesis of pornographic intention. The body they offer is not a

means to proscribed knowledge (as in Clemente), or a potential object of possession (as in Sherman), or even a challenge to social mores (as in Fischl). Instead, Salle's paintings offer something far less engaged – a world in which pornography is itself oddly irrelevant.

Salle's anomic rendering of the nude might indeed serve (and a number of his commentators have viewed it in exactly this fashion) as a metaphor for the relentless obliteration of the human subject under late capitalism were it not true that the body so reduced is invariably female. It is here that the feminist critique of Salle's work carries the most weight. When Salle posits a split between soul and body, he simultaneously establishes another along gender lines. There are, after all, some images of men in Salle's paintings, but they tend to embody the sphere of action, decision making, and societal constraint denied women. There are images of matadors (conquest and domination of brute animal force effected with the sexually charged saber); iconic profiles of Abraham Lincoln (frequently positioned suggestively over portions of a female body, perhaps as comment upon our culture's discomfort with the idea that public figures have private lives); bone-weary workers or fist-waving agitators; and assorted pop-culture or otherwise clichéd male characters including Santa Claus, Donald Duck, and Christopher Columbus. This last grouping overlaps with another of Salle's image categories – ethnographic-type representations of bare-bosomed or string-clad "natives." These seem to stand in the same relation to the active male principle as do Salle's women. In *Din* (1984), a group of nearly nude young tribal types of indeterminate sex kneel together, their attention captured by a fully three-dimensional object – it is in fact an attached wooden chair leg – that protrudes in unmistakably

phallic fashion from the canvas. In *Dusting Powders* (1986), the right half of the canvas contains a close-up portrait of a white female with coiling, pale, Medusa-like hair. Above and below her, like predellas in a medieval altarpiece, are two rows of repeated photo-transfer images representing string-clad aboriginal women posing stiffly before the camera.

Thus, in Salle's paintings, both woman and "native" are radically Other – the dark continent to be colonized and exploited but never wholly understood. This comparison is reinforced by the frequent appearance of primitivistic fertility sculptures whose basic forms seem clear stand-ins for the female nudes, and further supported by the fact that several Western women are provocatively, "primitively" attired only in leopard-spotted panties.

And so, in Salle's universe, the exploration of the body as "the location of human inquiry" leads back to long-established dualities between soul and body, man and woman, first and third worlds. The fact that he has so starkly delineated these divisions may help clarify their hold on the contemporary imagination, but ultimately it is hard to see how their reification can truly serve, as many of Salle's supporters insist, as a liberating force. Rather, Salle's paintings bring to mind the frightening specter of the body-object so chillingly experienced by Milan Kundera's Tereza in *The Unbearable Lightness of Being*. Tereza has an obsession with her physical body, and this pathology is in turn rooted in childhood:

When she lived at home, her mother forbade her to lock the bathroom door. What she meant by her injunction was: Your body is just like all other bodies; you have no right to shame; you have no reason to hide something that exists in millions of identical copies. In her mother's world all bodies were the same and marched behind one another in

formation. Since childhood, Tereza had seen nudity as a sign of con-centration camp uniformity, a sign of humiliation.[8]

In Salle's world this nightmare remains an especially female fantasy, just another reminder that in this culture, the body which woman is, can never be hers.

8. Milan Kundera, *The Unbearable Lightness of Being* (New York: Harper & Row, 1984), p. 57.

A Necessary Transgression

PORNOGRAPHY AND POSTMODERNISM

How did we get, in just a few short decades, from the celebratory "Make Love, Not War" to the sullen "Just Say No"? When did the sexual revolution turn into a rout, and how did the forces of sexuality, so briefly unleashed in the service of mental and physical health, turn poisonous again, leaving society with the daunting task of stuffing all those disruptive energies back into Pandora's box? Of course, we know some of the answers: AIDS, the conservative backlash, the resanctification of state, church, and family. But even all these retreats do not quite prepare us for the spectacle of radical feminists making common cause with Christian fundamentalists and antiabortion activists over the evils of pornography. Meanwhile, in the art world, where one might expect the libertine attitude to find its last refuge, there is indeed a vogue for quasi-pornographic imagery, but there is something peculiarly distanced, even, one might venture to say, puritanical, about the joyless, flattened image of sexuality provided by artists like Cindy Sherman, Eric Fischl, and David Salle.

I am going to suggest that there is a connection between these developments and argue that, beneath their apparent hostility, both camps share a mechanistic conception of human

nature that forecloses debate on the larger implications of both sexuality and pornography.

In an intriguing discussion of the findings of the 1986 Attorney General's Commission on Pornography, Thomas McEvilley points out that one of the issues pornography raises is "whether we create our images or they create us."[1] Both the postmodernists and the antiporn crusaders share the conviction that images create us. One of the key arguments of activists like Andrea Dworkin and Catherine McKinnon is that pornography not only replicates the unequal power relations in our society, but it also serves as an instrument by which they are enforced. The pervasiveness of pornography in our culture, they argue, creates an incitement to violence against women, teaching men to devalue women and women to acquiesce in their subjugation. Thus, in Susan Brownmiller's words, "Pornography is antifemale propaganda."

There are a number of hidden assumptions here – for example, that human beings operate according to a kind of stimulus-response model of behavior and that the solution to the evils of patriarchy is simply better social conditioning. A second assumption is that there is an equivalence between image and action, between representation of socially unacceptable acts and the acts themselves; hence, "Pornography is the theory, rape is the practice." Third (this is somewhat in contradiction with assumption 1), violence and aggressiveness are essential to the male psyche and the female, lacking these qualities, is inherently superior. For some of the most radical opponents of pornography, this leads to the conclusion that heterosexuality itself is suspect; that intercourse is always an expression of male

1. Thomas McEvilley, "Who Told Thee That Thou Was't Naked," *Artforum*, February 1987, p. 106.

113

power and hence a form of rape. The final assumption is that the patriarchal power structure is monolithic and all-encompassing and thus any mechanism supporting that structure is equally one-dimensional. In this vein, Dworkin argues, "Pornography is not a genre of expression separate and different from the rest of life; it is a genre of expression fully in harmony with any culture in which it flourishes."[2]

What is missing from this analysis is any acknowledgement of the mutability and multidimensionality of categories like power, identity, representation, and, most important, sexuality. Instead we are offered a series of fixed entities that stand above the flux of ordinary experience.

Turning to postmodernism, we find a similar tendency toward reduction. If the self as defined by the antipornography crusaders is the product of a relentless patriarchal system intent on confining the sexes to their preordained place in the power hierarchy, the postmodern self conforms to the brutal demands of the postindustrial machine, which shapes us into passive, insatiable consumers of goods, ideas, and enervating spectacle. In both systems, the freedom to act independently of these external forces is practically nil. Pornography is popular among postmodern artists because it offers a vivid symbol of the process by which we are remade into objects. Thus, in David Salle's paintings, potentially inflammatory images of splayed female nudes are treated with the same detached connoisseurship as the Eames chairs and kidney-shaped coffee tables attached to the canvas. The subversive potential of Eric Fischl's suburban oedipal dramas is undermined by a studied emptiness that distances the viewer and blocks any strong reactions of identification or disgust. And

2. Andrea Dworkin, *Pornography* (New York: Perigee Books, 1979), p. 25.

Cindy Sherman's pseudo-pinup self-presentations have (at least until recently) derived their impact from their subject's complicity with the camera, which acts as a surrogate for the objectifying male gaze.

For both the postmodernists and the antiporn crusaders, pornography is only tangentially related to sexuality. For the crusaders, it expresses the aggressive male Will to Power. For the postmodernists, it is really about the consumption of others and ourselves as one of the motors driving late Capitalism. (There seems to be some connection between this attitude and the curious fact that as sex becomes more problematic and unavailable in the age of AIDS, sexual references in advertising become ever more pervasive and explicit.) Hence for members of both camps, pornography is a system of representation entirely in sync with our oppressive society.

But if this is the case, what are we to make of the culture's general disapproval of pornography? Is the public outrage periodically directed by politicians, parents' groups, and religious organizations against "dirty" magazines, X-rated movies, and the like mere hypocrisy? Are we witnessing only a coy dismissal designed to mask these products' real function? If pornography reinforces the status quo, why do its most vociferous opponents also tend to be those most devoted to maintaining "traditional" values? What both the postmodernists and the antiporns seem to forget is that pornography is as transgressive as it is complicitous – that if it upholds the power of patriarchy or the culture of consumption, it also challenges sacred cows like the nuclear family, monogamy, heterosexuality, and the tie between sex and reproduction. Pornography, like sexuality itself, has a deeply subversive side. Efforts to domesticate either through the conundrum of "safe sex" or the specious distinction between

erotica and pornography (it has been noted that "erotica is what I like, pornography is what you like") fail to acknowledge that part of the fascination of each is exactly its potential for social disruption. As Susan Sontag points out:

Human sexuality is, quite apart from Christian repressions, a highly questionable phenomenon, and belongs, at least potentially, among the extreme rather than the ordinary experiences of humanity. Tamed as it may be, sexuality remains one of the demonic forces in human consciousness – pushing us at intervals close to taboo and dangerous desires, which range from the impulse to commit sudden arbitrary violence upon another person to the voluptuous yearning for the extinction of one's consciousness, for death itself.[3]

It is no accident that some of the greatest works in the modernist canon were once dismissed as fancy trash. Precisely because pornography focuses on those corners of human experience we might prefer not to acknowledge, it can offer the great artist a place to explore the limits of the possible. Because of its outsider status, it can also serve as an instrument for marginalized groups to challenge the prevailing norms of the system that excludes them. In the pre-AIDS era, the prodigious sexual activity of certain groups of male homosexuals provided a means of asserting the validity of their "deviant" sexuality against the mores of a complacently heterosexual culture. Similarly, during the seventies, a surprising number of women artists and writers adopted a quasi-pornographic content or form in order to assert the claims of female desire and sexuality as part of the women's movement's general challenge to patriarchy.

Currently, much of the ire directed by radical feminists against pornography is caused by the perceived rise in pornogra-

3. Susan Sontag, "The Pornographic Imagination," reprinted as an introduction to Georges Bataille, *Story of the Eye* (London: Penguin Books, 1982), p. 103.

phy that depicts sadomasochistic treatment of women. What tends to get lost in the brouhaha is the fact that it is virtually impossible to make clear-cut distinctions between "good" porn and "bad" porn, given the shadings of individual taste and sexual habits, and that some form of pornography has served every culture as a necessary outlet for otherwise inexpressible impulses and desires. Given pornography's current state of disrepute, this seems a good moment to look more closely at some potentially liberating uses of pornography as explored in the works of various contemporary artists.

Because the female body has served as the central focus of both the high art and the pornography of Western culture, it has become a matter of some controversy among feminist artists as to whether the female nude can ever be presented in art without reducing women to mere erotic objects. These concerns have led some to advocate a form of feminist iconoclasm. In her highly influential article "Visual Pleasure and Narrative Cinema," written in 1975 (the author has since somewhat modified her position), Laura Mulvey drew on psychoanalytic theory to establish that the source of our pleasure in the traditional Hollywood film lies in the way it replicates the gender definitions of patriarchal culture. Mulvey argues that

in a world ordered by sexual imbalance, pleasure in looking has been split between active/male and passive/female. The determining male gaze projects its fantasy onto the female figure, which is styled accordingly. In their traditional exhibitionist role women are simultaneously looked at and displayed, with their appearance coded for strong visual and erotic impact so that they can be said to connote *to-be-looked-at-ness*.[4]

4. Laura Mulvey, "Visual Pleasure and Narrative Cinema," reprinted in Brian Wallis, ed., *Art After Modernism* (New York: New Museum of Contemporary Art, 1984), p. 366

The only way out of this bind, Mulvey suggests, is a systematic destruction of cinematic pleasure through a refusal of the devices on which it is built.

Mulvey was writing about cinema, but her analysis is (and was) easily applied to art. The notion of woman constituted solely for and by the male gaze finds its clearest expression in recent visual art in Cindy Sherman's blank-faced ingenues and quivering girl-women serving themselves up to the camera as empty vessels for male fantasy. The weakness of the argument is its tendency, once again, to rigidify gender roles and identities, to suggest (echoes of Dworkin) that sexual desire is the exclusive province of the male, and to dismiss the possibility that the female might ever legitimately be the bearer of "the gaze" or find pleasure in sexual fantasies of her own.

Countering the iconoclastic strain in contemporary feminism, some women artists present images of the female body and/or sexual intercourse in order to focus on female sexual pleasure and response. In a series of paintings from the early 1970s, Joan Semmel explored the world as constituted by the female gaze, offering representations of nude women or couples as they would appear to the woman in question looking down the length of her own body. In performances and graphic works, Hannah Wilke displays herself in the coy and kittenish poses of the traditional girlie shot, adding her own commentaries ("Venus Envy," "Beware of Feminist Fascism") to redefine these images in the context of female sexuality.

Other artists have borrowed the conventions of pornography in order to expose our culture's unexamined assumptions about gender roles. In 1972, Linda Benglis made a provocative and highly controversial statement about the art world's con-

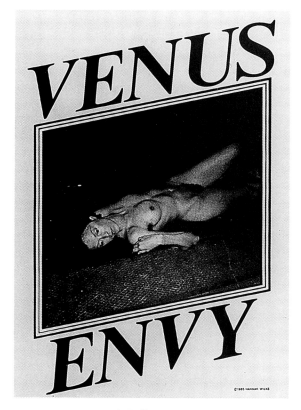

Hannah Wilke, *Venus Envy*

tinuing fondness for the macho male artist by announcing her upcoming gallery show with an ad in *Artforum* depicting herself prancing in the buff and sporting an enormous dildo. Meanwhile, in recent photographs by Cindy Sherman, the meek and naive personas of her previous work make way for hideous harridans and monsters who, often as not, stare challengingly back at the viewer. No longer passive vessels of the male gaze, these assertive and often threatening presences demonstrate that power relations are never fixed – that, in Michel

Foucault's words, "Power is everywhere, not because it embraces everything, but because it comes from everywhere."[5]

Among gay male artists borrowing the conventions of pornography, none has made more forceful and more disturbing work than Robert Mapplethorpe. His luscious, artful photographs of the sculpted black men with enormous penises or pairs of men outfitted in sadomasochistic regalia offer unapologetic images of an outlaw sexuality. The disturbing implications of white supremacy and self-inflicted violence produce images that refuse to ingratiate themselves to a heterosexual culture and cannot be assimilated into any "acceptable" vision of good sex.

Another interesting subdivision of quasi-pornographic images involves work that mocks the individuals and institutions that are the locus of power in our society. Peter Saul and the duo Cockrill and Judge Hughes both employ a deliberately offensive cartoon style to represent authority figures or groups. It is interesting to compare the latter's family portraits with those of Eric Fischl. Next to Cockrill and Judge Hughes's *Mad Magazine*–style depiction of grandfather and daughter lustily fornicating as parents indulgently look on, Fischl's well-painted oedipal dramas seem suddenly extremely tame. In a similar though less flamboyant vein are Anita Steckel's reworked photographs of Hitler and entourage sporting the enormous erections that symbolize our culture's identification of virility with power lust.

And finally, in a series of opulent watercolors, Joyce Kozloff points out the artificiality of what Thomas McEvilley refers to as Western culture's "dual image track," which assigns explicit

5. Michel Foucault, *The History of Sexuality,* Volume I: *An Introduction* (New York: Vintage Books, 1980), p. 93.

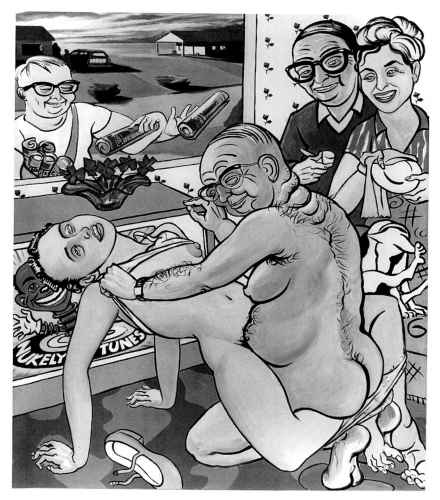

Cockrill/Judge Hughes, *The Weems*

sexual imagery to the underground pornographic tradition and idealized, usually female, nudity to high art. Kozloff's watercolors mix decorative patterns and pornographic imagery from a variety of cultures – Japanese, Chinese, medieval, classical Roman and Greek, and Himalayan – as well as private Western

121

Joyce Kozloff, *Pornament Is Crime Series #16, Classical Stations*

erotica from artists like Beardsley, Hogarth, and Picasso. Lifted from their original contexts and placed in connection with each other, these images suggest both the ubiquity of the pornographic imagination and the futility of our society's efforts to suppress the expression of this aspect of human experience.

Ultimately, any discussion of pornography and visual art must return to McEvilley's question: Do we create our images or do they create us? To accept only the latter half of the proposition, as the postmodernists and the antipornography crusaders do, is to reduce the human self and sexuality to a mere reaction machine. This leads, on the one hand, to the utopian fantasies of the antiporns, who anticipate the emergence of a pure, untarnished new man and woman once the evil influences of patriarchy are swept away and, on the other, to the dystopian nightmares of the postmodernists, for whom the individual is a mere cog in a soulless machine.

To accept as well the first half of the proposition is to own up to the darker sides of human nature and sexuality. These images appear in art and popular culture because they are a part of us. They burble up out of our repressed desires for extreme states of consciousness, for social transgression, for more fluid definitions of gender identity and sexual expression. Sontag suggests that in our desecularized society, pornography offers the only expression to the human "appetite for exalted self transcending modes of concentration and seriousness."[6] It also offers a means, via fantasy, to explore roles and activities that may be socially unacceptable, self-destructive, or politically incorrect. In the process, it can both broaden our conception of human nature and, by means of its distorted

6. Sontag, p. 11.

mirror, hold up for scrutiny the unexamined mythologies of our society.

The antipornography crusaders are right to suggest that pornography replicates unequal relations in our culture between men and women. It would be surprising if it did not, since it is a product of that culture. But we need not conclude, therefore, that pornography can and should be eliminated. As Angela Carter points out, "sexual relations between men and women always render explicit the nature of social relations in the society in which they take place, and if described explicitly, will form a critique of those relations, even if that is not and never has been the intention of the pornographer."[7]

We live, as Wallace Stevens pointed out, "in that old chaos of the sun / or that old dependency of day and night." We will not make our light blaze brighter by suppressing the darkness through which it shines.

7. Angela Carter, *The Sadeian Woman* (New York: Vintage Books, 1980), p. 93.

Pornography, Feminist Fundamentalism, and the Transcendence of Self

Not so long ago, pornography was, for most of us cultural workers, a rather esoteric issue. True, feminist crusaders like Andrea Dworkin and Catherine McKinnon were leading largely ineffective campaigns against the sale of pornographic materials in midwestern cities like Indianapolis and Minneapolis, but for the most part, intellectuals were content with the comfortable liberal line – it may not be my cup of tea, but as long as no one gets hurt. . . . In fact, it was quite possible to get along, navigating the shoals of deconstruction, postmodernism, and simulation, without having an opinion on pornography at all.

What a difference a few years makes! Today, as Jesse Helms and the American Family Association pore over lists of NEA grant recipients seeking evidence of obscenity, pornography has emerged as a major battleground in the war for the control of culture. Why has the Right chosen to make pornography the centerpiece of its battle against liberalism? Did the feminist opposition to pornography help lay the groundwork for the current battle? If pornography is merely, as the feminist opposition would have it, a reinforcement of a sexist, patriarchal status

quo, why do the most devoted defenders of that status quo so vehemently attack it?

The debate over pornography is not just a simple matter, as some would have us believe, of women's rights, moral decay, or taxpayers' money, on the one hand, or, on the other, of a simple defense of the First Amendment. The pornography issue brings to the fore a basic American uneasiness with sexuality, with nonconformity, with the existence of marginal groups and behaviors, with so-called deviant philosophies. It encapsulates our unresolved conflicts over the nature of liberty, democracy, social consensus, and community.

In a recent article in the *New York Times Book Review* on the burgeoning influence of fundamentalist religion in America, Robert Jay Lifton and Charles B. Strozier noted:

Fundamentalism represents a current in American life that has always lived side by side with, but in considerable opposition to, the Jeffersonian spirit of openness and questioning of authority. It imposes on all matters a quality of ideological totalism – of insistence on all-or-none judgments and positions. Fundamentalism thus exerts an expanding influence in the direction of absoluteness and closure at a time when flexibility and openness to new ideas are desperately needed.[1]

One of the most disturbing aspects of the pornography debate, which after all first became an issue in the hands of "cultural feminists"[2] like Andrea Dworkin, Susan Griffin, and Cath-

1. Robert Jay Lifton and Charles B. Strozier, "Waiting for Armageddon," *New York Times Book Review*, August 12, 1990, p. 25.
2. The distinction between "radical feminists" who are concerned with the material basis of patriarchy and pursue a program to minimize the sexual differences in society and the "cultural feminists" who emphasize the psychological dynamic at work in a patriarchal culture and focus on male behavior and the male role rather than structures of power is provocatively explored in Ann Snitow, Christine Stansell, and Sharon Thompson's *Powers of Desire: The Politics of Sexuality* (New York: Monthly Review Press, 1983), pp. 439–459.

erine McKinnon, is the evidence it provides that the Right has no monopoly on fundamentalist thinking. The Left as well as the Right in this country seem caught up in a fever of righteous anger that manifests itself in separatism; a divisive preoccupation with identity; a tendency to polarize the population along gender, ethnic, or sexual lines; and an appeal to some natural order or state of purity that is violated by a truly free expression of ideas and behaviors. The roots of these tendencies is a topic for another time, but for the purposes of this article, it is enough to point out that reductive thinking of the sort that underlies the feminist opposition to pornography has dangerous implications that go far beyond the case at hand.

What is the basis for the feminist opposition to pornography? What are the counterarguments? What lessons can be learned from this debate? Perhaps the most effective way to get to the heart of this controversy is to examine four texts, two on each side of the issue. Andrea Dworkin's *Pornography: Men Possesing Women*[3] is probably the most strident of the voices demanding the banning of pornography in the name of women's freedom. For Dworkin, pornography is simply one of the grosser manifestations of the male will to power. She writes, "Terror issues forth from the male, illuminates his essential nature and his basic purpose."[4] In her view, heterosexual sex is always a matter of violation of the woman by the man. "The woman is acted on; the man acts and through action expresses sexual power, the power of masculinity."[5] Thus pornography becomes a primary tool of male dominance. "Male power is the raison d'etre of

3. Andrea Dworkin, *Pornography: Men Possessing Women* (New York: Perigee Books, 1979).
4. Ibid., p. 16.
5. Ibid., p. 23.

pornography; the degradation of the female is the means of achieving this power."[6]

In prose marked by a rising note of hysteria, Dworkin offers blow-by-blow accounts of various examples of visual and written pornography, making no distinction between the banality of a *Hustler* cartoon, the mechanical repetitiousness of a stroke film, and the multiple layering in the "literary pornography" produced by the likes of Georges Bataille and the Marquis de Sade. She includes as well carefully selected quotations by respected scholars and psychologists like Sigmund Freud, Michael Kinsley, and Havelock Ellis that she uses to prove their complicity in the maintenance of the patriarchal culture.

Pounding away with an analysis that leaves no room for nuance, ambiguity, or ambivalence on the part of her evil conspirators, she has produced a text that is a model of fundamentalist thinking. In her black-and-white universe, the essences of male and female natures are fixed – the one forever a terrorist, the other forever (or at least until the roles are reversed) a victim.

Dworkin's position has been much criticized within the feminist community for its divisiveness, its heterophobia, its denial of female sexual pleasure and desire, and its basic puritanism. Nevertheless, her equation of pornography and violence against women has been persuasive enough to spur feminist groups around the country to demonstrate and lobby, unsuccessfully to date, for local laws to make the sale of pornographic materials illegal.

A far more thoughtful but still deeply flawed effort to press the feminist case against pornography appears in Susan Grif-

6. Ibid., p. 24.

fin's *Pornography and Silence.*[7] The subtitle of this book, *Culture's Revenge Against Nature,* sums up her argument. She constructs a rather questionable psychology in which the adult male, having lifted himself out of nature and into the state of culture, must punish woman – the embodiment of nature – in order to compensate for the frustration he felt as a child at his dependence on his then all-powerful mother. But in the process of punishing woman, he is also destroying that part of himself that is feminine, and therefore nurturing, feeling, and whole.

In this scheme, the pornographer serves as an instrument of this nature-annihilating culture. Pornography's real function is the obliteration of natural feeling:

All death in pornography is really only the death of the heart. Over and over again, that part of our beings which can feel both in body and mind is ritually murdered. We make a mistake, therefore, when we believe that pornography is simply fantasy, simply a record of sadistic events. For pornography exceeds the boundaries of both fantasy and record and becomes itself an act. Pornography *is* sadism.[8]

Griffin ends her book with a vision of a world in which the reign of nature is restored and sexuality returned to a condition of wholesome eroticism:

erotic feeling brings one back to this state of innocence before culture teaches us to forget the knowledge of the body. To make love is to become like this infant again. We grope with our mouths toward the body of another being, when we trust, who takes us in her arms. We rock together with this loved one. We move beyond speech. Our bodies move past all the controls we have learned. We cry out in

7. Susan Griffin, *Pornography and Silence: Culture's Revenge Against Nature* (New York: Harper & Row, 1981).
8. Ibid., p. 83.

ecstasy, in feeling. We are back in a natural world before culture tried to erase our experience of nature. In this world, to touch another is to express love; there is no idea apart from feeling, and no feeling which does not ring through our bodies and our souls at once.[9]

This is a very lovely fairy tale, but unfortunately it has nothing to do with real life. The opposition of nature and culture, and the identification of the former with woman, the latter with man, are tenets of a now largely discredited vision of human nature that feminism itself has been at pains to dispel. Like the simplifications of Dworkin – that sex is rape, that pornography is a form of violence against women – Griffin's thesis is based on a simplistic view of human psychology in which the male represents mind, aggression, and power and the female represents feeling, nurturance, and victimhood. Although, unlike Dworkin, she is willing to allow for the possibility of female sexual satisfaction, this satisfaction is essentially an infantile one that takes place under conditions that none of us is likely to discover again.

The feminists who oppose pornography share with their fundamentalist colleagues a belief that there is an unchanging natural order of things. They are preoccupied with correct and incorrect behaviors and thoughts (they make no distinction between fantasy and action), correct and incorrect sexual activities and orientations (for some of the more extreme cultural feminists, heterosexuality is a form of consorting with the enemy), and they prefer to consider sexuality as an autonomous entity, removed from the vagaries of history, politics, and social reality.

So it should not surprise us if the rhetorics of cultural feminism

9. Ibid., p. 254.

130

and fundamentalism occasionally converge, even when their larger agendas stand in apparent opposition. As feminist anthropologist Gayle Rubin remarks:

Feminist rhetoric has a distressing tendency to reappear in reactionary contexts. For example, in 1980 and 1981, Pope John Paul II delivered a series of pronouncements reaffirming his commitment to the most conservative and Pauline understandings of human sexuality. In condemning divorce, abortion, trial marriage, pornography, prostitution, birth control, unbridled hedonism and lust, the pope employed a great deal of feminist rhetoric about sexual objectification. Sounding like lesbian feminist polemicist Julia Penelope, His Holiness explained that "considering anyone in a lustful way makes that person a sexual object rather than a human being worthy of dignity."[10]

Alice Echols adds, "More generally, the anti-pornography crusade functions as the feminist equivalent of the anti-abortion movement – reinforcing and validating women's sense of themselves as the culture's victims and its moral guardians."[11]

By contrast, the more thoughtful commentators who have mounted a defense of pornography strive to present a multilayered account of culture and human sexuality. Two such accounts will be considered here. Angela Carter's *The Sadeian Woman*[12] is a provocative consideration of the writings of the Marquis de Sade. While not absolving Sade of denigration of women, she attempts to go beyond the flat, surface readings proposed by Griffin and Dworkin and examines the texts from

10. Gayle Rubin, "Thinking Sex: Notes for a Radical Theory of the Politics of Sexuality," in Carol C. Vance, ed., *Pleasure and Danger: Exploring Female Sexuality* (Boston: Routledge & Kegan Paul, 1984), p. 298.
11. Alice Echols, "The Taming of the Id: Feminist Sexual Politics, 1968–83," in Vance, ed., *Pleasure and Danger*, p. 65.
12. Angela Carter, *The Sadeian Woman and the Ideology of Pornography* (New York: Pantheon Books, 1978).

a variety of vantage points. There is, first of all, the way in which any pornographic text, even the most banal and mechanical, contains within it a mirror, however distorted, of the social and sexual relations between the men and women of the society in which it has been written. In the work of Sade, Carter finds a second level of interest, suggesting that in fact his writings comprise a guerrilla action against the repressive society in which he lived and that they attack that society using arguments that are really just a distorted mirror of that society's own Enlightenment reasoning. The principle of human equality becomes a justification for theft, freedom is defined by the arbitrary exercise of power, and sexual libertinage is a form of communal ownership of property.

In Sade's inverted universe, conventional morality is merely a cloak used to disguise politics. His heroines – Justine, the savagely misused victim, and her sister Juliette, the corrupt and terrifying whore – are two sides of a society in which privilege always and inevitably leads to tyranny. Thus, for Sade, Carter notes, "Feminine impotence is a quality of the poor, regardless of sex. Juliette is an exception; by the force of her will, she will become a Nietzschian superwoman, which is to say, a woman who has transcended her gender but not the contradictions inherent in it."[13]

Ultimately, although Sade resists his society, he cannot truly escape it. His inverted rationalism remains tied to a vision of human nature as absolute in its way as that of Dworkin and Griffin. Carter describes his world view: "The strong abuse, exploit and meatify the weak, says Sade. They must and will devour their natural prey. The primal condition of man cannot

13. Ibid., p. 86.

be modified in any way; it is, eat or be eaten."[14] In the end, then, he creates a horrifying inverse of the utopian fairy tale that ends Griffin's book:

Juliette, as Theodor Adorno and Max Horkheimer say, embodies "intellectual pleasure in regression." She attacks civilization with its own weapons. She exercises rigorously rational thought; she creates systems; she exhibits an iron self-control. Her will triumphs over the barriers of pain, shame, disgust and morality until her behavior reverts to the polymorphous perversity of the child, who has not yet learnt the human objections to cruelty because, in a social sense, no child is yet fully human. Her destination has always been her commencement. The triumph of the will recreates, as its Utopia, the world of early childhood, and that is a world of nightmare, impotence and fear, in which the child fantasizes, out of its own powerlessness, an absolute supremacy.[15]

Able to examine Sade on many levels, to accept his limitations as well as his insights, and to put his writings into a historical context that illuminates their relationship to Enlightenment rationality, Carter suggests how pornography may function simultaneously as a reinforcement of and an instrument of resistance to the status quo. A similarly complex reading appears in Susan Sontag's "The Pornographic Imagination,"[16] which examines examples of "literary pornography," including Georges Bataille's Story of the Eye and the pseudonymous Story of O, to investigate the hidden meanings of pornography.

For Sontag, pornography is a forum for the pursuit of kinds of knowledge that are otherwise foreclosed by our culture. One of these is the truth of sexuality, which is revealed by pornogra-

14. Ibid., p. 140.
15. Ibid., p. 148.
16. Susan Sontag, "The Pornographic Imagination," reprinted as an introduction to Georges Bataille, Story of the Eye (New York: Penguin Books, 1982).

phy to be something quite other than the healthy, "natural" appetite as defined by modern liberal thinking. She argues, "Tamed as it may be, sexuality remains one of the demonic forces in human consciousness – pushing us at intervals close to taboo and dangerous desires, which range from the impulse to commit sudden arbitrary violence upon another person to the voluptuous yearning for the extinction of one's consciousness, for death itself."[17]

Another repressed truth that pornography exposes is the modern person's unmet need for the kind of experience of self-transcendence and exaltation that is provided by religion in cultures less secular than our own. Sontag says:

Most pornography – the books discussed here cannot be excepted – points to something more general than even sexual damage. I mean the traumatic failure of modern capitalist society to provide authentic outlets for the perennial human flair for high temperature visionary obsession, to satisfy the appetite for exalted self-transcending modes of concentration and seriousness. The need of human beings to transcend "the personal" is no less profound than the need to be a person, an individual. But this society serves that need poorly. It provides mainly demonic vocabularies in which to situate that need and from which to initiate action and construct rites of behavior. One is offered a choice among vocabularies of thought and action which are not merely self-transcending but self-destructive.[18]

Sontag, like Carter, is willing to concede to pornography a variety of roles, some restrictive of human experience and potentially destructive, some expansive and even necessary. In contrast to the fundamentalist stand taken by Dworkin and Griffin, for whom the removal of pornography and the suppression of

17. Ibid., p. 103.
18. Ibid., p. 115.

male aggression will make possible a clean and tidy world safe for the expression of wholesome female sexuality, she acknowledges the complex and contradictory nature of the human personality and human society.

In the end, an examination of the two orientations toward pornography discussed in this article suggest why pornography is currently the focus of the Right's attack on culture. The opposition to pornography, whether it comes from feminists or from the American Family Association, is grounded in a kind of utopian thinking that celebrates a homogeneous, dissent-free model of society. Pornography, whatever else it is, is a reminder of disruptive realities, of the untidy nature of the human personality, of the shifting and unpredictable nature of power within society and within personal relationships, of the unresolved tensions and inequities created by the inescapable fact of Difference. It is no coincidence that the artists who have been the primary targets of the Right's ire – Robert Mapplethorpe, David Wojnarowicz, Andres Serrano, Karen Finley, Holly Hughes, 2 Live Crew – are representatives of marginal groups and "deviant" outlooks, be they gay, black, Hispanic, lesbian, or female, or that they use the conventions of pornography in their work as a weapon against the comfortable moral certainties of the dominant culture.

One of the lessons behind the failure of communism in Eastern Europe is that utopian thinking leads to tyranny and repression. In the United States, tests of political correctness and charges of ideological betrayal are becoming commonplace both on the Left and on the Right. There seems to be a loss of faith in the viability of the public realm as a place to thrash out differences of opinion and a concurrent desire to impose upon a contentious society values derived from some supposedly higher moral ground.

But morality, as Sade himself teaches, may easily be a mask for matters of politics and economics. Jesse Helms's real target is less likely to be the godlessness of obscenity than the imposition of a sweeping conservative agenda that involves a rollback of women's rights, workers' rights, affirmative action, and free speech. Thus, although pornography may seem a peculiar and even distasteful standard under which to make a stand for liberty, at the moment it seems to be one of the most effective rallying points we have.

Enter the Other

MULTICULTURALISM AND ITS
DISCONTENTS

The Whole Earth Show

Buffeted by glasnost, the Third World debt crisis, and an influx of refugees from all corners of the globe, the West's longstanding faith in its own powers of self-determination has of late come under heavy fire. In academic and artistic circles, one consequence of this crumbling confidence is a newly fashionable fascination with the Other, which threatens to join the Heroic Sublime and the Primal Self in the pantheon of the governing myths of twentieth century art.

In Paris (May 1989), the Other received a full-dress reception, complete with an official luncheon with the Minister of Culture on the occasion of the opening of *Magiciens de la Terre,* billed as the first attempt to present a truly international art exhibition. One hundred artists from both the major art centers and such normally peripheral locations as Haiti, India, Madagascar, and Panama were selected for the show by a curatorial team headed by Jean Hubert Martin, director of the Musée National d'Art Moderne, in consultation with a variety of local advisors.

Despite efforts to forestall charges of Western ethnocentrism, including the selection of a title in which the word "art" is conspicuously missing, the exhibition came under almost imme-

diate attack. Benjamin Buchloh, in an interview published in *Art in America* in May, raised serious questions about the premise of the show, and in a review in the *New York Times* published several days after the opening, Michael Brenson asked, "What happens when many of the artists who make nonmarketable religious art go home and no Western art official calls again? Will they feel they have been exploited by a French curatorial vision?"

And indeed, the questions the exhibition raises go to the heart of Western culture's proprietary relationship toward the developing world. Can there really, one wonders, be any continuum between a Kiefer painting and a Benin ceremonial mask? How does one make judgments of quality about objects so completely foreign to our culture and experience? Is there any politically correct way to present artifacts from another culture or does the museological enterprise inevitably smack of cultural exploitation? Wary of the tendency to romanticize the lost purity of vanished worlds, the organizers have emphasized societies in transition, in many cases choosing Western and non-Western artists who represent an exchange of influence between their respective cultures. Still, one wonders if such exchanges are really equivalent. Is the same thing going on when an artisan from Madagascar incorporates airplanes and buses within the traditional tomb decorations of Madagascar and when Mario Merz appropriates the igloo or hut form into his sculptures?

The exhibition is spread over two sites. At the Pompidou Center, works are arranged in small rooms in the familiar group show format, while within the open glass-enclosed space of the Grand Hall at la Villette, one feels at times as if one had wandered into an ethnographic museum or one of those grand nineteenth-century expositions of art and culture. This impression is en-

hanced by the presence in the Grand Hall of a variety of re-creations of traditional religious and ceremonial structures. There is, for instance, an intricately carved house whose center-piece is an elaborate mandala from Nepal that was created by three Buddhist monks laboriously blowing paint through straws in the Grand Hall during the week before the exhibition's open-ing. Nearby, the facade of a Benin voodoo house provides the backdrop for an arrangement of cult statues whose carnivalesque air is mixed with intimations of ritual violence. The work's cre-ator, Cyprien Tokoudagba, found it necessary to sacrifice a chicken to ensure that the higher powers would not be angered by the inclusion of these magical objects in an art show.

Works like these, so far removed from Western definitions of art, suffered most from the curatorial decision to include only the names of each work's creator and geographical location in the wall labels. Intended to ensure all works equal treatment, this lack of information encouraged viewers to apply preexist-ing Western aesthetic standards to objects for which such stan-dards are irrelevant.

This was less of a problem with works that belong to the "evolving" category and reveal a self-conscious interface with Western culture, modern technology, or the world art market. The Yuendumi, for instance, are a group of Australian aborigines whose sand paintings play a role in their initiation rites and normally are constructed in the desert. Recently, however, in response to Western interest, the Yuendumi, like other aboriginal groups, have begun creating paintings for exhibitions such as this one. Eager to participate in the Western art establishment, they enthusiastically welcomed the placement of a color-coordinated mud circle by Richard Long on the adjacent wall.

In the category of traditional forms subtly, or not so subtly

altered by a brush with Western influence, two of the most strik-
ing installations were a house painted by South African artist
Esther Mahlangu and burial totems created by an artist from
Madagascar named Efiaimbelo. Houses of the sort painted by
Mahlangu are traditionally replastered and decorated by women
in connection with circumcision rites. A certain leeway in
composition is permitted, and Mahlangu's apparently abstract
designs, crisply delineated in a manner easily assimilable to mod-
ernist standards of taste, in fact incorporate highly stylized im-
ages of objects like telephones and televisions. Efiaimbelo's
carved and painted wooden totems were more reminiscent of
Western folk art and offered the charm of mixed cultural sym-
bols. These decorated poles were as likely to be topped with
buses and motorcycles as with more traditional tableaus of war-
riors or farmers.

The exhibition also contains works that have, to Western eyes,
a certifiably "native" look but that actually reflect newly minted
forms. The fantastic papier-mâché animals of the Linares family
in Mexico owe a certain kinship to traditional Day of the Dead
artifacts but in fact constitute a tradition created by the family
patriarch. Patrick Vilaire, from Port au Prince, creates oversized
bronze chairs that bear similarities to traditional Haitian art but
that reflect a personal iconography having to do with the vari-
eties of power.

The most interesting group of works in the show – and the
ones around which a more coherent exhibition might have been
built – was produced by non-Western artists conversant in the
subtleties of Western culture and interested in the interplay be-
tween these traditions and their own. Japanese artist Hiroshi
Teshigahara, better known in the West as the director of the film
Woman of the Dunes, created the most striking installation at the

Pompidou. Mimicking the building's pop-constructivist archi-
tecture, he created a coiling bamboo corridor nestled next to a
glass view through which a visitor could glimpse one of the
glass tubes that are the Pompidou's trademark. "Japonesque" in
spirit and material, "Western" in form and context, the work
straddled cultures in an extremely sophisticated manner.

Other works in this category were more pointed in their
presentation of intercultural tensions. Rasheed Araeen, a Paki-
stani artist living in London for twenty years, frames his reflec-
tions on Britain's lingering neo-colonialism in works that adopt
a very up-to-date mix of photographs, text, and minimalist and
constructivist forms. His contribution to the exhibition played
upon a series of shocks creating confrontational juxtapositions:
images of modern British riot police with a voluptuous harem
girl, for instance, or, in the middle of the room, an open cube
structure reminiscent of the work of Sol Lewitt with a pile of
animal bones.

Cheri Samba, from Zaire, came across as an African Sue
Coe. Trained as an illustrator, he employs the form of the propa-
ganda poster to make uncompromising and sometimes wick-
edly funny observations about the seamier aspects of contempo-
rary African life. Among the paintings, which generally contain
text, often presented as dialogue between figures drawn in a
caricature style, several dealt with sexual politics and the disrup-
tion of traditional family harmony, while another, in which a
motley parade of demonstrators was juxtaposed with an image
of a man dying in bed, managed to convey both practical infor-
mation and a discussion of the social and personal dilemmas
presented by AIDS.

More subtly subversive, thanks to its shimmering beauty,
was an installation by Brazilian artist Cildo Miereles. He con-

structed a cavelike enclosure, bathed in golden light with backlit cow bones hanging like stalactites over a thick carpet of gold coins. Connecting floor and ceiling, and suggesting the status of the Brazilian Catholic Church as a link between the worlds of spirit and commerce, was a single stacked column of communion wafers.

In a category of their own were a pair of Chinese artists whose idiosyncratic works are truly outside and against the narrowly defined official culture. Reflecting on the clash between ancient traditions and modern industrial culture, Yongping Huang sculpted newspaper that had been ground to a pulp in modern washing machines into the form of traditional burial mounds. Similarly transforming the debris of industrial society, Gu Dexing lined the walls of a small room with a dense accumulation of brightly colored bits of burned and melted plastic, creating a weirdly expressionistic environment that brings to mind the installations of Judy Pfaff.

Playing off the unfamiliar faces was a cast of well-established Western artists, including Kiefer, Polke, Kruger, and Clemente, many of whose presence in international exhibitions has apparently become de rigueur, whatever the show's ostensible theme. In general, their relation to non-Western culture took the form of adaptation or appropriation of form (Mario Merz's woven straw hut, Boltanski's shadow figures), vague spiritual affinity (the mythic origins of Kiefer's paintings), or, in a few cases, political critique (Dennis Adams's farewell to colonialism, Alfredo Jaar's dramatization of toxic waste dumping off the coast of Nigeria). Along with the usual suspects, there were some interesting choices that suggest how a more sensitive handling of the Western selections might have helped clarify the premises

of the show. A roomful of Nancy Spero's scroll-like drawings revealed a Western artist borrowing "primitivistic" motifs, not from the usual position of cultural dominance but to explore her own sense of marginality within a patriarchal culture. John Baldassari contributed a collage of film and media images that revealed the stereotypes and clichés that permeate representation of the non-Western world in American popular culture.

The organizers' decision to attribute all works to individual makers, regardless of the degree of their adherence to predetermined traditional forms, as well as their emphasis on cultures in states of transition, reflect an awareness of the theoretical debates currently raging within the disciplines of anthropology and ethnography. By rejecting the tropes of original purity and static tribal culture held by more classically oriented specialists in favor of an evolutionary view, this exhibition manages to avoid the worst failings of the Museum of Modern Art's 1984 *"Primitivism"* exhibition, which was the last major effort to come to terms with intercultural encounters.

At the same time, however, the choice of the word "magiciens" in the title and the recurring references to spirituality in the introductory catalog essays suggest a second agenda that is more problematic. The focus of ritual and holy objects, the revelation of how the debris of modern industrial society is recovered and incorporated by Third World artists, and the emphasis, in both Western and non-Western works, on quasi-religious content is rarely accompanied by an acknowledgment that interactions between the First and Third worlds are frequently not so exemplary. With a few exceptions, notably Araeen, Jaar, and Samba, there is very little sense here of the reality of power politics or of the fact that conditions of influ-

ence are not parallel. The Western artist who borrows the forms or "spirit" of a dominated culture still remains in a position of dominance, while the Third World artist who incorporates materials and motifs from the developed world remains an outsider. One might see both of these forms of borrowings as efforts to appropriate the "magic" of the other culture, but in the real world such magics are finally nontransferable.

Ultimately, despite the organizers' efforts to avoid the more obvious manifestations of paternalism, the exhibition remains suffused with the Romance of the Other. In his introductory statement, Martin expresses a hope that the introduction of the spiritual concerns of non-Western artists into the world art scene may inject a badly needed counter to the crass commercialism of Western art.

One is reminded of Claude Levi-Strauss's confession about the psychological origin of the anthropologist's fascination with other cultures. He remarks, "But if he [the anthropologist] is honest, he is faced with a problem: the value he attaches to foreign societies - and which appears to be higher in proportion as the society is more foreign – has no independent foundation; it is a function of his disdain for and occasionally hostility toward the customs prevailing in his native setting."[1]

Anxious to discover an alternative to the spiritual bankruptcy of our own culture, Martin and his team avert their eyes from many of the darker aspects of Western – non-Western encounters – the continuing exploitation of the Other by the dominant powers, for instance, or the presence of an often embattled Third World within the First World itself.

The value of this exhibition lies in the issues it raises, how-

1. Claude Levi-Strauss, *Tristes Tropiques,* trans. John and Doreen Weightman (New York: Atheneum, 1975), p. 436.

ever inadequately they are addressed, and the quality of some of the newcomers it introduces. Still, it leaves an odd aftertaste. For all its celebration of the exotic and different it remains oddly familiar, reminding us that to seek in the Other a reflection of our idealized self is never to leave home at all.

Against Nature/Primal Spirit

TWO VIEWS OF CONTEMPORARY JAPANESE ART

Until recently, the disciplines of anthropology and ethnography seemed marooned in an academic backwater, awash with seedy romantics searching amid the "primitive" cultures of the world for their fantasies of lost Edens or orgies of primal passion. Of late, however, these fields of study have become sexy, thrust into the intellectual limelight by a fascination with the Other as a theoretical construction of the dominant culture. Meanwhile, real-world events like the ending of the cold war and the emergence of a worldwide economic system have rendered convenient binary opposition like East versus West, democracy versus communism, nature versus culture, and us versus them obsolete. As a result, even the art world has become caught up in questions about identity and difference, the relativity of cultural values, and the difficulties of making judgments across ethnic, gender, class, and cultural lines.

A pair of exhibitions on tour in 1990 throughout the country present the work of contemporary Japanese artists in ways that throw these issues into high relief. Working from contrasting premises, they suggest very different answers to such questions as: How do we regard the Other? How do we respect Differ-

ence without either romanticizing or domesticating it? What constitutes the essence of a culture? Do we regard evidence of its interminglings with outside traditions as important data or mere static? Taken together, these exhibitions may tell us as much about our own cultural biases as they do about developments on the other side of the globe.

A Primal Spirit: Ten Contemporary Japanese Sculptors, organized by Howard Fox in a collaboration between the Los Angeles County Art Museum and the Hara Museum of Contemporary Art in Tokyo, represents an effort to discover in certain manifestations of contemporary Japanese art a uniquely Japanese sensibility that is rooted in Shinto attitudes about humanity and nature. Noting that Shinto proposes a vision of nature as a kind of inner spirit permeating all animate and inanimate things, Fox remarks in the catalog introduction, "Though the work in *A Primal Spirit* is altogether secular, its deep spiritual content is reflected in dark and terrible forms built from the elemental things in nature – trees, rocks, minerals – that reveal primal forces of growth and change, creation and destruction, life and death."[1]

The works he has chosen are composed of materials like wood, clay, tar, palm fiber, and oxidized sulfur and their forms, hewn from whole tree trunks, charred as if from ceremonial burning, or pieced together in rudimentary shapes that suggest mountains, waterfalls, rock quarries, or crumbling ancient ruins, suggest an aspiration to the sublime. As installed at the Los Angeles County Art Museum, this sense of drama was accentuated by theatrical lighting that brought out an almost ritualistic dimension in some of the works.

This ceremonial flavor was particularly marked in the work

1. Howard N. Fox, *A Primal Spirit,* exhibition catalog (Los Angeles: Los Angeles County Museum of Art, 1990), p. 26.

of Toshikatsu Endo, who, along with Tadashi Kawamata, is one of the most internationally prominent artists in the show, having made appearances at the 1988 Venice Biennale and Documenta 8 in 1987. The centerpiece of his installation was a charred wood ring that suggested some sort of cooking or burial pit. To the side was a circle of stones, some of them also discolored with soot. Burning is an important element in Endo's work. He notes in the catalog, "I am not making some form, creating some figure, through the use of fire; fire as a phenomenon is what I'm interested in."[2]

This willingness to abandon one's creative self to the dictates of materials or natural processes is a key element in what Fox argues is the Shinto-influenced aspect of this work. Another of the artists here, Chuichi Fujii, creates strikingly simple works out of massive cedar tree trunks bent into only slightly unnatural curves and curls. He is quoted: "I had been seeking a means of expressing the life force of the wood, and it was this form that naturally emerged."[3] Equally process oriented are the structures created by Takamasa Kuniyasu. Formed of red clay blocks and neatly severed logs woven together in undulating walls that wrap around corners, doorways, and pillars like some sluggishly advancing organism, they also suggest an order of creation that is not humanly directed.

In other works the hand of the artist mimics the abrasive handiwork of wind and water. Shigeo Toya presented a stand of upright wood blocks whose upper portions had been scored and gouged away to create patterns of cuts that suggested crystalline growths or paths carved by shifting water rivulets. In an arrangement of driftwood scraps by Kimio Tsuchiya, softly

2. Ibid., p. 55.
3. Ibid., p. 57.

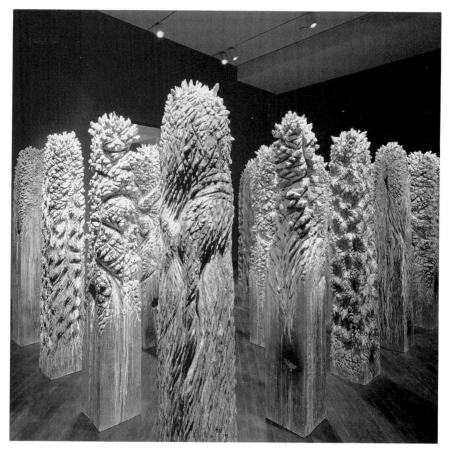

Shigeo Toya, *Woods II*

rounded slabs of wood cascaded down the wall and across the floor like stones worn smooth by a waterfall.

Fox's selections of work here, his discussion in the catalog, and the theatrical mode of presentation together serve to reinforce his assertion that the true Japanese spirit, as manifested in contemporary art, has nothing to do with Western modernism. He has asserted, "Most of the contemporary Japanese art in

major exhibitions has been selected because it derived from Western art. What's been overlooked is the fact that other artists are working in ways that are very original and have nothing to do with Western modernism. They are creating visual forms which are unique in international art today."[4]

Such claims are not wholly convincing. There is, first of all, the fact that the idea of fine art, as opposed to craft or decoration, is an extremely recent addition to Japanese culture, dating back no more than a century and clearly imported from the West. Thus, the very genre in which these artists are working – the autonomous art object – represents a break with traditional culture. Then there is the fact that many of the characteristics of this work that Fox finds incompatible with Western notions of art – such qualities as the surrender to the "inner spirit" of materials, the effacement of the individual creator, and the emphasis on process over product – have certainly enjoyed important roles at various times in the history of the Western avant-garde, especially in the antimaterialist sixties and seventies, a period when in fact there was a great deal of cross fertilization with the West in the work of Japanese artists like Yayoi Kusama, Yoko Ono, Arakawa, and On Kawara.

Even within the show itself, this aura of timeless purity is challenged by the work of Tadashi Kawamata. Recognized by Western audiences for installations at Documenta 8, the 1987 São Paulo Bienal, and the 1982 Venice Biennale, Kawamata is known for his elaborate configurations of wooden beams that seem to grow willy-nilly from the preexisting buildings that serve as their host. In Los Angeles, Kawamata stretched his construction through the glass wall separating the exhibition gallery from the

4. Ibid., p. 67.

outside plaza and allowed it to thread upward across a second-story passageway connecting one building to another. In the catalog Kawamata discusses his work in terms of urbanism and the collapse of public and private space, rather than in relation to some sort of Shinto-influenced animism, and in fact remarks staunchly, "That there is a Japanese quality in Japanese art is something that countries other than Japan have invented. In any case, I don't think Japanese [artists] have made anything with a 'Japanese quality.' "[5]

The other end of the conceptual spectrum is represented by *Against Nature: Japanese Art in the Eighties,* an exhibition organized by an international team composed of Kathy Halbreich, Thomas Sokolowski, Shinji Kohmoto, and Fumio Nanjo. Challenging the kind of essentialist thinking that underlies *A Primal Spirit,* Halbreich and Sokolowski note in their catalog introduction, "The artists included in *Against Nature* gnaw at dated colonialist views, both foreign and domestic, of a Japan and an indigenous Japanese art form that is rooted in a traditional agrarian view of the land and man's responsibility to it."[6]

Against Nature focuses on the assimilative tendencies in contemporary Japanese art, presenting the work of ten younger artists who take the Japanese absorption of Western pop culture, high art, and technology as their point of departure. It has become a cliché to point out that the Japanese have historically created their culture out of a kind of proto-postmodern pastiche of elements borrowed and stolen from the cultures of their conquests, just as it has become fashionable to maintain that as the Japanese strive

5. Conversation with the author, July 1990.
6. Kathy Halbreich and Thomas Sokolowski, in Forward to *Against Nature: Japanese Art in the Eighties* (New York: Grey Art Gallery and Study Center, New York University, 1989), p. 8

for economic dominance over the West, their culture becomes, at least on the surface, more American than America's.

As if corroborating this view, in *Against Nature* a kind of Baudrillardrian flux seems to hold sway, as references to such diverse sources as Grimm's fairy tales, Greek mythology, biblical tales, sci fi movies, comic books, Western history painting, and gothic sculpture collide in unexpected combinations. Yet, even at their most familiar, there are for the Western viewer of these works unassimilable undercurrents in which one might seek something irreducibly "Japanese."

For instance, the work of Tatsuo Miyajima, an artist who has begun to receive considerable attention on the international scene, involves the use of digital electronic technology in a way that seems to play into contemporary discussions of the disappearance of the "real." He creates room-sized installations in which the darkened space flickers with the incessant movement of randomly programmed electronic numbers. These environments have been variously interpreted as dramatizations of the loss of self in the electronic age, shrines for a postindustrial age, and investigations into an existential experience of time and space. Is Miyajima's point of view ironic or celebratory, spiritual or materialist, utopian or dystopian? Eventually the Westerner begins to suspect that such comfortable oppositions do not apply.

Similarly, the work of Yasumasa Morimura initially seems extremely accessible. Working in the mode of Cindy Sherman, he stars as the principal figure in photographic tableaus that recreate various masterpieces of Western art. But instead of exploring the construction of individuality, Morimura's photographs have more to do with the artifice of culture itself. On the one hand, they explore cross-cultural misunderstandings through a

Yasumasa Morimura, *Portrait (Shounen II)*

focus on works that display traces of Western orientalism –
Manet's *Olympia,* Ingres's odalisques, Nijinsky's neo-primitive
choreography. On the other hand, they seem to make reference
to the stylized nature of Japanese behavior as it reaches its peak in
the figure of the female impersonator.

And so it continues throughout this intriguing exhibition. Katsura Funakoshi's haunting half-figure sculptures hover in a peculiarly indeterminate way between specific ethnic, sexual, and historical identities. Noboru Tsubaki's giant neon yellow pod erupts with spikes, scales, ruptures, and leaves, dominating the gallery like some nuclear nightmare of mutant fertility, as if in defiant challenge to the conventional Western clichés about the Japanese oneness with nature. Yusei Ogino's elaborate installation conflates the legends of Icarus and St. Michael the archangel in a tableau that seems to be an elegy to the artist/craftsman, while Shoko Maemoto rends Cinderella-style ball gowns with gaping rivers of red as a commentary on women's life in Japan.

What becomes clear is that the artists here are using references and motifs borrowed from the West to speak of conflicts and values within their own culture. Just as the Japanese adopted the written language of the Chinese in order to adapt it to their own use, here they seem to be appropriating the forms of Western art and culture for their own purposes. As a result, for the Western viewer there is a danger in assuming too much about a subtext that can only be imperfectly grasped. This show demonstrates that even a direct focus on the cultural interchange between East and West does not eliminate the difficulties inherent in the effort to comprehend the Other.

The current ferment in anthropology hinges on a tension between the notion of culture as an originating source from which all of society's later permutations spring and the notion of cultures whose intermixings form their essence. In his acclaimed ethnographic study *The Predicament of Culture,* James Clifford argues for a middle ground between these extremes:

Modern ethnographic histories are perhaps condemned to oscillate between two metanarratives: one of homogenization, the other of emergence; one of loss, the other of invention. In most specific conjunctures both narratives are relevant, each undermining the other's claim to tell "the whole story," each denying to the other a privileged Hegelian vision.[7]

The truth of the meaning of contemporary Japanese art would seem to lie somewhere between the romanticism of *Primal Spirit* and the pragmatism of *Against Nature*. For despite their best efforts to the contrary, it seems clear that both shows are tinged by Western biases. Both, for instance, hinge on the importance of nature in Japanese culture. *Primal Spirit* searches behind the façade of industrialization for an authentic encounter with an essential experience of nature, while *Against Nature,* as its title implies, suggests that its artists embrace technology, urbanism, and popular culture as a rebellion against such romantic notions. Yet in both cases, the underlying assumption is that nature and culture, countryside and city, spiritualism and materialism are in fundamental opposition. But what if we are dealing with a culture where these polarities do not hold? To what extent is the schema suggested by these two shows – static purity pitted against free-floating appropriation – just another reflection of the dualistic thinking that dominates Western culture?

7. James Clifford, *The Predicament of Culture* (Cambridge, Mass., and London: Harvard University Press, 1988), p. 17.

The New Word Order

In an essay entitled "Politics and the English Language," George Orwell warned against the dangers of the politicization of language by ideologues of any stripe. Pointing out that euphemism, obscurantism, and buzzwords make clear thinking all the more difficult, he offered a spirited defense of clarity in writing and speech. Today we seem to be living in another era when the meaning of certain words is constantly changing and nothing is quite what it seems. Currently, for instance, words that once seemed to represent neutral or even salutary concepts – "universality," "quality," "assimilation," "European modernism" – have become shorthand for a reactionary adherence to a program of neocolonialism and cultural imperialism. In their place are a new set of terms, among them "difference," "relativism," "cultural diversity," and "the Other."

The point of this shift of terminology is to underline the fact that the melting pot is out and the assertion of ethnic, racial, and gender identity is in. In keeping with this new world order, Marcia Tucker recently expressed what seems to be a widely held sentiment: "museum administrators have to reeducate themselves completely. We must read the new art histories, we must

read theory in order to put ourselves in touch with all culture. We must learn to listen, keep our eyes and ears open and stop speaking for others."[1]

There is something troubling about this wholesale rejection of Western attitudes, education, and language. For although this challenge to the dominant cultural paradigms is indeed a response to real demographic changes and real pressures from those excluded from the last decade's very one-sided prosperity, it also masks certain less laudatory agendas. Multiculturalism, currently sweeping campuses with the thoroughness of a midwinter flu, crowding out other, less fashionable topics at conferences and official gatherings, also fortuitously provides institutions like the academy, the art world, and the entertainment world the opportunity to expand their reach to much needed new constituencies.

And it is suddenly everywhere – the subject of panels, scholarly publications and books, art exhibitions, popular newspaper articles and television programs, the focus of efforts to rewrite high school and college curricula, manifesting itself even in a revised language of liberalism that requires the substitution of terms like "African American" and "people of color" for the older and evidently more prejudicial "black" and "minority."

If the shift from a Eurocentric to a multicultural paradigm were simply a matter of opening up the canon, of rethinking exclusionary standards and providing a space for a more inclusive dialogue, it would be hard to argue with its program. However, these days, multiculturalism often threatens to harden into dogma as epithets like "racist," "sexist," and "homophobic" are brandished by the politically correct like

1. Marcia Tucker, quoted in Maurice Berger, "Are Art Museums Racist?" *Art in America,* September 1990, p. 74.

cudgels wielded to beat down the possibility of genuine exchange.

A few cases in point: "The art world is one of the most racist institutions in America."[2] "[T]he demand for assimilation is a subtle and insidious form of racism."[3] "I never believe white people when they tell me they aren't racist. I have no reason to. Depending on the person's actions I might possibly believe that they are actively engaged in opposing racism, are anti-racist, at the very same time they continue to be racially ignorant and cannot help but be influenced as white people by this system's hatred of people of color."[4] "I often feel when I cross Houston Street over into SoHo, that I am crossing the Mason/Dixon Line."[5]

It would be absurd to deny the existence of real inequities in the art world's representation of nonwhite artists (although this probably has less to do with overt racism than with such economic realities as the function of mainstream art as a luxury good and the nature of the support system that has been erected for that function). But is the art world really the moral equivalent of David Duke's Louisiana? Is it really as exclusionary as, say, the average corporate boardroom?

Such statements set up an unbridgeable chasm between Whites (specifically White males) and Others. The mere fact of

2. Maurice Berger, statement made during a panel discussion held at the School of Visual Arts, New York City, October 4, 1990, entitled "What's Going on with Whiteness?", moderated by Berger.
3. John Yau, "Official Policy," *Arts,* September 1989, p. 51.
4. Barbara Smith, quoted in Eunice Lipton, "Here Today. Gone Tommorrow?" in *The Decade Show,* exhibition catalog (New York: The Museum of Contemporary Hispanic Art, The New Museum of Contemporary Art, and The Studio Museum of Harlem, 1990), p. 25.
5. Howardina Pindell, "Covenant of Silence," *Third Text,* Summer 1990, p. 75.

cultural difference becomes an insurmountable barrier to communication and common action. Any effort by members of the "oppressor class" to cross ethnic, racial, or gender lines in order to gain knowledge of the Other is an act of cultural imperialism. But if Whites can never escape from the contamination of racism, neither can the Other break the confines of his or her Otherness. Both "oppressor" and "victim" are locked into roles that limit their potential for growth.

Critics have referred to the resulting stalemate as "cultural apartheid" or the "new tribalism." To this way of thinking, society is divided into a series of armed camps, each immersed in a mortal combat for control of the social, political, and cultural apparatus. In this battle, any defense of any aspect of European culture is seen as an attack on non-European culture, efforts to make discriminations based on some notion of "quality" are considered imperialist, and any effort to look at one culture through the eyes of another is an act of violence to that culture.

The contradictions inherent in this version of multiculturalism surface in a variety of ways. Actor's Equity's misguided attempt to apply affirmative action to the casting of the principal role of *Miss Saigon* almost resulted in the loss of a significant number of Broadway roles for Asian-American actors while setting in place a principle that, if applied across the board, would be as limiting to actors of color aspiring to "White" roles as vice versa. Multiculturalism can be limiting intellectually as well. In October 1990, *The Village Voice* reported on the denial of reappointment of a Hispanic professor of cultural studies at Hampshire College apparently for taking an overly "Eurocentric" approach to his subject. In both these cases, multiculturalism, far from dismantling hierarchies, merely attempts to invert them. What Abdul R.

JanMohamed refers to as the "manichean opposition of the colonizer and colonized"[6] remains in place, its terms simply reversed. In the brave new world of multiculturalism, it would seem, to paraphrase Orwell, some are more Other than other Others.

Among Left-leaning white intellectuals, there is currently a fashion for litmus tests of ideological purity and cathartic confessions of one's complicity with hegemonic power structures. The February 18, 1991, issue of *The New Republic* was devoted to the subject of race on campus. It reported that at Oberlin College, dormitory counselors are taught in a required antiracism seminar that "all whites are racist and only they can be racist," while at Smith College, students receive a sheet from the Office of Student Affairs proscribing all types of bias, including "ableism – oppression of the differently abled by the temporarily able," "ageism," and "lookism" – the advantaging of people by physical attractiveness.

The problem with such celebrations of liberal guilt is that they misdirect attention away from the real causes of inequity, away from the role played by class and privilege in the perpetuation of oppression and discrimination and toward a hermetic examination of individual feelings and motives. But in the end it is action, not attitude, that matters. Proponents of multiculturalism who adopt a stance of moral superiority risk turning the white world into a monolithic force for the destruction of people of color when in fact a recognition of the multifaceted nature of power would allow them to see where real inroads might be made.

A case in point is the often virulent criticism from Leftist

6. Abdul R. JanMohamed, "The Economy of Manichean Allegory: The Function of Racial Difference in Colonialist Literature," in Henry Louis Gates, Jr., ed., *"Race," Writing and Difference* (Chicago: University of Chicago Press, 1985), pp. 78–106.

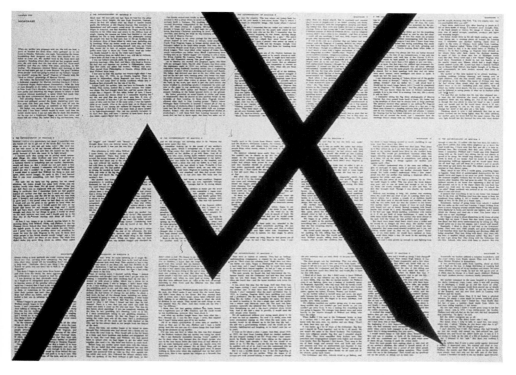

Tim Rollins and Kids of Survival, *By Any Means Necessary – Nightmare*

commentators of what is seen as Tim Rollins's racist exploitation of the black and Hispanic teenagers who make up the Kids of Survival. Rollins is described as a white male who uses children of color "to further launder the image of the artworld and assuage liberal guilt."[7] In his direction of the workshops' attention to books like Kafka's *Amerika* and Stephen Crane's *Red Badge of Courage,* he fails "to be significantly engaged by multicultural texts or issues."[8]

7. Pindell, p. 88.
8. Michele Wallace, "Tim Rollins + K.O.S.: The 'Amerika' Series," in Gary Garrels, ed., *Amerika: Tim Rollins + K.O.S.* (New York: DIA Art Foundation, 1989), p. 45.

What goes unremarked here (aside from the fact that the Kids have worked with *The Autobiography of Malcolm X* and borrow from a remarkably diverse and multicultural set of sources) is the fact that Rollins has found a way to use the existing art patronage system to make a profound difference in the lives of a group of disadvantaged adolescents. While it will be clear to anyone who has met the Kids that they have not been transformed into a group of white bread cultural turncoats, they have been given some tools for assimilation into the mainstream culture.

Which brings us back to the moral status of assimilation. The uncompromising assertion of each group's unique ethnic, racial, or gender identity plays well in the academy right now, but on the streets this attitude is a prescription for social anarchy. The racial tensions and polarizations that seem to worsen every day in New York City are exacerbated by a spirit of uncompromising hostility between groups of have-nots whose much publicized animosity conveniently obscures the economic roots of the problems of crime, homelessness, and poverty. In the real world the more extreme forms of multiculturalism can become a tool of demagogues from both the Left and the Right, used to consolidate their own power at the expense of the groups they purport to represent.

Possibly the greatest danger currently facing American society is the decay of the public sphere and the disintegration of the public interest into an atomized collection of narrow localized, and often ethnically defined special interests. The social chaos and pointless destruction that result from such balkanization are only too obvious elsewhere in the world – in the bloody clashes between Sikhs and Hindus, Slovenes, Croats, and Serbs, Rumanians and Hungarians, the African National Congress and the

Zulus, and, last but not least, the Baltic states and the Soviet Union.

In a recent article on the decline of democracy in America, Lewis Lapham described the ideal from which we have so egregiously fallen. "Democratic government is a purpose held in common, and if it can be understood as a field of temporary coalitions among people of different interests, skills and generations, then everybody has need of everybody else."[9]

Militant multiculturalism rejects this ideal, scornfully dismissing visions of a more egalitarian society capable of addressing and reconciling the conflicting needs and desires of its various constituencies in a peaceable fashion as naive and utopian. But the alternative to the liberal dream would seem to be an ever more divided society where charges and countercharges drown out the few embattled voices calling for a search for common ground. Unless we find some way to pass messages across cultural and racial battle lines, we seem likely to bury ourselves beneath the ruins of our own Tower of Babel. With the common projects of social justice and preservation of freedom cast into disarray by the confusion of tongues, we will be lost in fruitless combat with adversaries who ought to be our friends.

9. Lewis H. Lapham, "Democracy in America?" *Harpers,* November 1990, p. 56.

Identity Politics at the Whitney

Rejecting the frivolity of Biennials past, with their Day-Glo bathrooms and stainless steel bunnies, the 1993 Whitney Biennial declares itself as sober and instructive as the times demand. This first Biennial, organized under the directorship of David Ross, was put together by a curatorial team headed by Ross-appointed curator Elizabeth Sussman. Rejecting the old pretense of inclusivity, the team has instead produced a tightly focused exhibition that returns again and again to contemporary artists' concern with racism, sexuality, gender, ethnic identity, and multiculturalism. Seeking what Sussman refers to as a "representation of a refigured but fragmented collectivity," this show purports to bring us political art for the nineties.

Can this really be the same exhibition that the Guerrilla Girls targeted in 1987 for its longstanding practice of racial and sexual exclusion? The vast majority of the 1993 participants – half of them video or performance artists – are members of "marginalized" populations – women, African Americans, Asians, Latinos, and gays. They are, as a group, far younger than the usual Biennial crew, and many are connected to galleries not usually represented in the show. Along with essays from mu-

seum insiders Sussman, Thelma Golden, John Hanhardt, and Lisa Phillips, catalog texts were commissioned from Homi Bhabha, Avital Ronell, Coco Fusco, and B. Ruby Rich, all thinkers known for their interest in cultural diversity. Like Clinton's cabinet, designed to make up for decades of white male dominance, this was an exhibition carefully tailored to look more like America.

The drive for social veracity was also reflected in the artists' choices of media and materials. Although painting, particularly abstract painting, was in scant supply, much of the work incorporated photographs, documentary material, texts, objects, and artifacts charged with social and political meanings. In the most extreme instance, this realism extended to the inclusion of George Holliday's camcorder video of the Rodney King beating as one of the video offerings. In a slightly more artful vein, bundles of newspapers, tied as if for recycling, were scattered throughout the building. Reprinted from actual New York newspapers on archival paper, the headlines, articles, and advertisements on their exposed pages were slightly modified by Robert Gober to highlight such issues as sexuality, AIDs, and gay rights. Other installations offered readings on the nation's current preoccupations through arrangements of dog-eared paperbacks, video rental boxes, and museum shop reproductions.

If, as it would seem, the purpose of this Biennial was to take the pulse of America, its vision is of a nation mired in racial, ethnic, and sexual conflict, still reeling from the Los Angeles riots and the Clarence Thomas hearings, and deeply ambivalent about "difference" at the same time that the fact of diversity becomes ever more inescapable. One of its sustaining themes is the politics of representation. Artists explored such questions as:

Who speaks for whom?, How is identity constructed?, and How may marginalized groups muster the power to define themselves? This is hardly uncharted territory – in fact, the terms of this debate were initially set by feminist thinkers during the seventies. Their explorations of the social construction of femininity laid the groundwork for the expansion, during the eighties, of the notion of "difference" to considerations of ethnic and sexual as well as gender identity. Although these issues are widespread in galleries and in the world at large, this is the first time the Whitney has attempted to grapple with then in a sustained fashion, and Sussman is to be credited with attempting to open the museum to voices rarely heard there.

Less to her credit is the strident tone that dominates this exhibition. Although some of the artists offer complex visions of social relations and the human personality, many of the most prominent works simply target the white male power elite as the source of all evil. They offer a litany of wrongs – among them neocolonialism, domestic violence, and ethnic stereotyping – but because they do not transcend the dichotomy of victim–oppressor, they cannot look beyond the powerlessness of the victims to the possibility of action and change.

The problem in many cases is a simplistic psychology that views identity as something externally imposed. An installation by Leone and McDonald gives the notion of cultural encoding a literal twist by hanging a set of branding irons from the ceiling. Burned into sheets of paper hung on surrounding walls, the brands imprint apparently abstract marks that are in fact notations from the Gregg shorthand system for words relating to sexuality. Another kind of cultural determinism, this time originating in childhood, is suggested by Robert Gober's sculpture of a crib made from a giant mousetrap. Even works that take a more

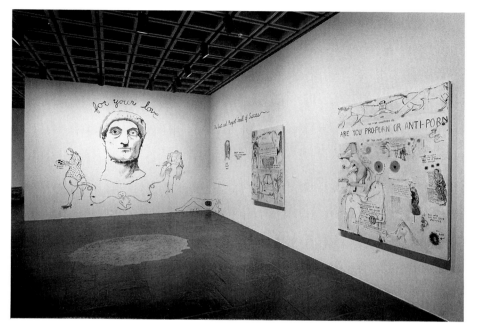

Installation view from the 1993 Whitney Biennial Exhibition (left to right): Sue Williams, *The Sweet and Pungent Smell of Success, It's a New Age, Are You Pro-Porn or Anti-Porn?*

complex view of the human personality tend to view it in isolation from larger political and economic forces, so that larger inequities are viewed as extensions of interpersonal relationships.

Thus, Sue William's angry scrawlings critique women's unequal place in society by raging at the abuse visited upon women by their partners in heterosexual relationships. Her raw, cartoonish paintings are augmented here by a large installation dominated by a Roman emperor's head and, on the floor, a sprawling circle of plastic vomit. Thus she links bulimia to the antifeminist values of Western civilization, seeing female self-abuse as a natural reaction to oppressive social pressures. This is

not the only work that explores bulimia as a symbol of the oppressive social pressures that deform women's image of themselves. Janine Antoni chews huge blocks of lard and chocolate and spits the material out. The gnawed blocks form one part of her sculptural installation. The installation also includes a boutique corner where chewed lard has been transformed into lipstick and chocolate into heart-shaped candy containers, emblems of the conflicting demands of beauty and consumption that lead women to binge and purge.

A related theme is the pervasiveness of racial stereotyping in a white-dominated society. Again, this tends to be viewed apart from the historical forces and economic competitions that bring groups into conflict. Pat Ward Williams's blown-up photograph in the museum's front window depicts a group of black youths who stare at the viewer behind a scrawl of graffiti that demands, "What you lookn at?". Presumably addressed to the primarily white passersby who frequent Madison Avenue, this work seems to reduce racism to a matter of relationships between individuals and suggests that it is best countered by the tactic of reciprocal intimidation.

The division of the world into powerful and powerless continues in other works. Fred Wilson's *Re: Claiming Egypt* is a quasi-museum display that purports to be an attack on the imperialistic practices of museums. In fact, consisting of Egyptian museum shop replicas and printed T shirts, it only obliquely makes its point, which seems to be the promotion of an Afrocentric version of history. According to this unsubstantiated but highly popular dogma, the originating contributions of black Egyptians have been purposely withheld from the narrative of Western history by racist historians. Gary Simmons's police lineup of golden running shoes takes on racism in the

Installation view from the 1993 Whitney Biennial Exhibition: Fred Wilson, *Re: Claiming Egypt*

criminal justice system. Also somewhat confused in its mix of references, it points, on the one hand, to racism as the ultimate reason for the disproportionate incarceration rate for young black men and, on the other, to a consumer-mad society that inculcates the kind of value system that leads young men to kill for a pair of running shoes.

In a similar spirit, Daniel Martinez has contributed two works designed to reveal the hidden assumptions about race and identity that underlie the privileged elite's world view. An installation re-creates a littered child's playhouse that contains an inventory of the adverse influences – violent cartoons, toy guns, cowboy

figurines, and so on – that shape the lamentable male psyche. Martinez also designed the admission buttons for Biennial visitors, which require them to wear all or part of the words from the phrase "I can't imagine ever wanting to be white."

Other works seem designed to enforce a simplistic notion of diversity. Mike Kelley's mock campus banners salute a variety of collegiate groups ranging from Christian dramatists to the African Student Union. Byron Kim presented an installation of small monochrome canvases matched to the skin tones of various friends and acquaintances. Placed in random order to form an elegant, minimalistic grid on the wall, they illustrated the rather unremarkable fact that people come in many different colors.

These and other artists often take the tone of hectoring school-marms, humorlessly admonishing their charges on their moral and behavioral failings. Meanwhile, another group of artists here seem to celebrate a kind of aimless abandonment to adolescent daydreams. Karen Kilimnik's tabloid-inspired musings on the vices and virtues of various celebrities, Raymond Pettibon's desultory scribblings about religion, the possibility of an after-life and how we got here, and Jack Pierson's snapshot-quality photographs of friends and surroundings celebrate an aesthetic of narcissism and antimastery. It is instructive to compare Pierson's vacant images of his milieu with Nan Goldin's compelling depictions of her AIDS-devastated world. What is missing in Pierson's work (deliberately so, it would seem) is the passion and engagement that give Goldin's photographs their tragic beauty. A similar indifference to communication (despite some words embedded in the paint) characterizes Suzanne McClelland's tangled paintings, among the very few examples of that medium in the show.

The work of these first-time Biennial participants seems little

related to the larger theme of the show. Instead, this incarnation seems markedly less entertaining than many earlier ones. These "Slacker" artists, as they have been dubbed in homage to Richard Linklater's 1991 film, are less innocent than simply vacuous. One wonders if their affectless acceptance is a kind of avoidance of complexity not so dissimilar from their sterner associates' fondness for finger shaking and victim finding.

Still, it would be wrong to give the impression that none of the artists in this Biennial are capable of nuanced reflection. There are some complex and powerful works here. Cindy Sherman's Hans Bellmar-inspired photographs of reconfigured mannequins touch on the primitive impulses that underlie human sexual expression. The power and honesty of these genuinely shocking works makes the cartoon vision of a Sue Williams pale by comparison. The complicity of victims in their own violation is also suggested by Ida Applebroog, whose painting installation spills out onto the floor, with small propped canvases scattered willy-nilly in the viewer's path. Inverting the moralistic message of traditional fairy tales, she evokes their dark terrors while debunking the mythical innocence of childhood. Her children are both victims and future perpetrators, entwined in vines, wielding guns, growing up to be Nazis.

Myth debunking is also a mission of Glen Ligon's photo and text installation devoted to a consideration of Robert Mapplethorpe's *Black Book*. The latter, Mapplethorpe's portfolio of photographs devoted to the black male nude (including the notorious *Man in a Polyester Suit*), has racist undercurrents that do not mesh well with the prevailing myth of Mapplethorpe as a liberator of gay sexuality. But rather than simply bash Mapplethorpe, in the manner of many of the other works here, Ligon intersperses the photographs with texts gathered from Mapple-

thorpe's critics, supporters, and casual viewers of the portfolio. Thus, he is able to pose some challenging questions about the nature of human desire, which is not always rational, politically correct, or reducible to predetermined categories.

Another work that is provocative rather than polemical is Charles Ray's *Family Romance*. Father, mother, young son, and toddler daughter stand nude in a row in this realistic figural tableau like one of those charts of human development. However, the parents have been scaled down and the children scaled up so that they are all slightly smaller than the average adult. Like the best work in this exhibition, this piece suggests multiple readings – ranging from a meditation on the child's fantasy of mastery over its parents to a revelation of the suppressed sexuality of the family unit.

Pepon Osorio's elaborate installation re-created a murder scene in an unbelievably kitschified Hispanic home. The purpose of the work, at least according to the wall label, was to offer a critique of pop culture's clichés about Latino life. In fact, however, the installation's vitality overshadowed any such dour academic point. Similarly engaging was *The Year of the White Bear*, a performance work by Coco Fusco and Guillmero Gomez-Pena, which ran for a few days during the opening of the exhibition. The two performance artists outfitted themselves as gorgeously show-biz "natives" and occupied an elaborately decorated cage while guides explained their antics and culture for a White Eurocentric audience's entertainment. Although it covered familiar ground, the performance's playfulness and flashy appeal lifted it above other works devoted to an exposé of the neocolonialist attitude.

Meanwhile, the exhibition's video section was removed this

year from its usual ghetto and situated instead in two promi-
nently placed viewing rooms on the third and fourth floors.
The video medium is in many ways more amenable to a multi-
faceted view of the issues of the show. Of the videos on display
early in the Biennial's run, Mark Rappaport's witty "discovery"
of a gay sexual subtext in Rock Hudson's films was particularly
engaging.

There are also several successful works that seem to have
nothing to do with the declared theme of this Biennial. It seems
to be really stretching to suggest, as Elizabeth Sussman does in
her catalog essay, that Gary Hill's remarkable *Tall Ships* em-
bodies a sense of community. This work consists of a dark
tunnel whose walls are lined with a series of ghostly interactive
video figures that walk toward and then away from the viewer,
who, by moving through the space, triggers their approach
mechanism. This work is more evocative of a fantasy realm of
spirits and doppelgängers than of the embattled social milieu
explored by other artists. Similarly, Chris Burden's *A Fist of
Light,* which overwhelms the downstairs lobby gallery, is a
mysterious aluminum apparatus that seems to lock away a dan-
gerous potential energy. A metaphor both for a literal bomb
and perhaps for a barely contained social fury, it relates only
tangentially to the rest of the work on display.

Taken as a whole, the 1993 Biennial is noteworthy not so
much for the quality of the art it presents but for the way it
mirrors certain disturbing trends within and outside the art
world. One such trend is the tendency of artists, curators, and
art educators to reduce contemporary art to the role of social
work or therapy. Much of the work here is numbingly didactic,
easily summed up in a sentence or two. In a curious way, this

tendency to privilege social message over aesthetic considerations parallels the attitudes of the religious Right in its demand that art be morally uplifting.

Even more disturbing, however, is the way the Biennial mirrors a widespread tendency today to reduce complex social issues to a politics of identity. Borrowing from the victim language of pop psychology and therapy, identity politics ignores economic and social determinates like class, religion, and nationalism, offering instead a simplistic model of society as a battle between victims and oppressors. Lacking more complex explanations for current conflicts, its simplistic psychology tends to see inequities as problems of attitude. Gober's mousetrap is emblematic here, seeking the cause of a dysfunctional society in a dysfunctional childhood. In the most simpleminded cases, racism, sexism, and homophobia are seen as voluntary prejudices that can be eradicated by proper reeducation.

By focusing on the psychology of hatred and oppression, this Biennial gives short shrift to the real domestic political issues like poverty, homelessness, and crime, to say nothing of larger global problems like war, ethnic cleansing, and incipient fascism that lie behind these conditions. In fact, questions of global politics arise only in works by Alan Sekula and Francesc Torres, whose presentations are unfortunately not among the more effective in the show. Instead, space allotments ensure that bulimia emerges as one of our major social problems.

Thus, instead of representing "cultures at the 'borderlines,' " as Homi Bhabha suggests in his catalog essay, or the "artworld . . . as a collectivity of cultures," in Sussman's phrase, the 1993 Biennial ends up trivializing the notion of political art. Adhering to the increasingly questionable notion that "the personal is political," it opts for a myopic view of the social realm.

Issues like urbanism, environmentalism, labor, nationalism, and religious conflict are seen as outside a narrowly conceived notion of community. In fact, communities are as much a function of shared values and common interests as they are sites of contest. But these issues have no place in a show that seems to view community only as a collection of angry, irreconcilable interests groups.

Trend conscious as ever, this Biennial would have us believe, as Lisa Phillips puts it in her essay, that "Today, everyone's talking about gender, identity, and power." In fact there are scores of artists dealing with social issues of a very different sort. Some commentators have used the show as a referendum on political art and have seen its failings as symptomatic of the tendency as a whole. But the problem here isn't that the politics have outrun the art. The problem is that there really wasn't much in the way of substantive politics in the first place.

The Problematics of
Public Art

The New Social Sculpture

As the gallery system grows increasingly bloated and the art market increasingly geared to the whims of fickle and often dismayingly ill-informed collectors, public art begins to feel like the last battleground of the avant-garde. Here, it seems, is a venue free of crass commercial concerns where artists may touch upon vital human issues and interact with a broad, unjaded, general audience. In fact, however, this idealistic appraisal has recently become the subject of heated debate as various writers have begun to question public art's hidden biases.

In a recent *Artforum,* Patricia Phillips notes:

In short, the making of public art has become a profession, whose practitioners are in the business of beautifying, or enlivening, or entertaining the citizens of modern American and European cities. In effect, public art's mission has been reduced to making people feel good – about themselves and where they live. This may be an acceptable, and it certainly is an agreeable, intention, but it is a profoundly unambitious and often reactionary one.[1]

1. Patricia C. Phillips, "Out of Order: The Public Art Machine," *Artforum,* December 1988, p. 93.

In *October,* Rosalyn Deutsche puts it even more bluntly: "This is the real social function of the new public art: to reify as natural the conditions of the late capitalist city into which they hope to integrate us."[2]

At issue here is the meaning of the word "public" – the question of whether location alone suffices to transform a work of art into a piece of public sculpture or whether the public artist bears some responsibility for the larger social, political and cultural concerns that make up the "public world."

To clarify, we might consider two examples of recent public art. First is Richard Serra's recently dismantled *Tilted Arc.* The controversy surrounding this work revolved around issues such as the integrity of the artist's vision, the responsibility of the city toward its public art commitments, and the rights of the local workers and passersby to recover the use of "their" plaza. Serra's work was site specific – cutting a swath through a bleak architectural complex in such a way as to dramatize its inhumanity. As more than one commentator pointed out, the angry reaction of local residents was evidence that they "got" the message. In its severe and oppressive beauty, then, *Tilted Arc* appears not so much a work of public art as the imposition of a private sensibility upon a public space.

The second example, by contrast, is profoundly uncontroversial. The elegantly minimal plaza furniture of Scott Burton offers a stylish affirmation of the corporate vision. In both material (polished marble and granite) and form, his blocky tables, chairs, and benches willingly conform to the requirements of a corporate culture that has found the aesthetic of modernist architecture and minimal art eminently suitable for

2. Rosalyn Deutsche, "Uneven Development: Public Art in New York City," *October,* Winter 1988, p. 19.

the cultivation of an image of cultural sensitivity and social responsibility.

Although they exist at opposite ends of the public art spectrum, these two examples are united by a failure to grapple with the real complexities of the public context – Serra by reenacting the old standoff between avant-garde artist and philistine public, Burton by conceiving of the public as some kind of uniform mass unproblematically joined by common interests. Much of the public art proliferating throughout our cities and towns, thanks to percent-for-art laws, revolves around one or the other of these poles.

Recently, however, a third approach to public art has begun to surface in the work of artists like Dennis Adams, Alfredo Jaar, Krzysztof Wodiczko and Jenny Holzer that conceives of the city as a locus of competing interests, ideologies, and languages, and infiltrates preexisting forums and forms in order to dramatize rather than resolve conflicts inherent in modern life.

In each case, the artist has chosen to frame unwelcome or potentially disruptive information within an institutional setting normally reserved for the exhortations of advertising or the affirmation of public values. Dennis Adams, for instance, has adapted the structures of urban bus shelters, public urinals, sales kiosks, and construction signs, Alfredo Jaar's best-known public piece was spread across the advertising panels of a downtown Manhattan subway station, Krzysztof Wodiczko's projected images use the façades of public and corporate buildings as their stage, and Jenny Holzer adopts the technology and format of the electronic advertising sign.

Searching for a label for this new tendency, one might do worse that Joseph Beuys's "social sculpture," for although it may not necessarily take the form Beuys anticipated, this new

public art does seem to respond to the Beuysian call for an art that "releases energy in people, leading them to a general discussion of actual problems" and which "would mean the cultivation of relations between men, almost an act of life."[3]

Although there are some overlaps, each of the social sculptors here has defined specific areas of concern. Alfredo Jaar, for instance, a Chilean-born sculptor now living in New York, has made his focus the perceptual distortions and power disparities between the developed and underdeveloped worlds. His public and gallery works typically incorporate documentary-type photographs within light boxes arranged in a way that both dramatizes their content and makes problematic the viewer's relationship to them. Sometimes the images are gathered from news archives. Or a news item may send Jaar halfway across the globe to take photographs of a situation that brings out the conflicts that most interest him.

Four years ago he traveled to Brazil to record the Herculean efforts of a settlement of ragged laborers drawn to a remote jungle of the eastern Amazon by rumors of gold. Jaar's photographs reveal the mud caked miners as they scale the ever-widening walls of an enormous pit bearing heavy bundles of dirt on their shoulders. Last fall he flew to the coast of Nigeria to check on reports that U.S. ships were dumping hazardous waste just offshore. Again, his photographs focused on the human dimension of the situation – the impoverished villagers for whom the waste dumps are at once a genuine health hazard and a source of potentially valuable American castoffs. In both cases, what interested Jaar about the situations was the dramatization they provided of the unequal relationship between members of the developed and

3. Quoted in Eric Micahud, "The Ends of Art According to Beuys," *October,* Summer 1988, p. 41.

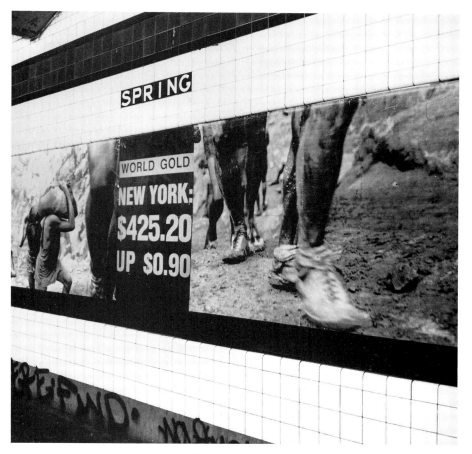

Alfredo Jaar, *Rushes*

underdeveloped worlds. The Brazilian gold miners willingly immersed in a Dantesque nightmare to provide their more fortunate neighbors with their most prized symbol of luxury and the Nigerian scavengers searching for prizes amid the waste products of American industry both illustrate an attitude that the Other is simply there for the developed world's convenience.

Jaar is currently at work on a series of works that will incorporate the Nigerian images. The Brazilian photographs have formed the basis for three major installations, one at the 1986 Venice Biennale, one at the Grey Art Gallery in New York, and one in the Spring Street subway station in Manhattan, where Jaar arranged them within the display areas normally occupied by liquor and movie advertisements.

This last work, which confronted Manhattan commuters with unexplained images of toiling preindustrial workers, was designed to catch the eye and provoke the imagination of an urban audience that has learned to gloss over the usual blandishments of advertising and art. Dennis Adams, whose public works have appeared in the streets of cities in the United States and Europe, makes a similar appeal. A series of functioning bus shelters, built in a constructivist style and housing illuminated photographic images, present reminders of repressed social conflicts or troubling historical events. On 14th Street in downtown Manhattan, a shelter incorporated an archival image of the arrest of Ethel and Julius Rosenberg (a husband and wife convicted and executed as Soviet spies during the cold war), which occurred near the site. Later this was replaced by a photograph taken by Adams of a local homeless man, which offered a poignant reminder of the human costs of the area's rapid gentrification. An image from the trial of Nazi Klaus Barbie, then taking place in Lyon, appeared on a shelter designed for the 1987 *Skulptur Projekte* in Münster, Germany, and a photograph of a demonstration by Native Canadians disputing land rights was incorporated within a shelter erected in Toronto in December 1988.

In other works, Adams has usurped the form and function of other pieces of urban furniture; a recent project in Geneva involved the signs normally placed around construction sites.

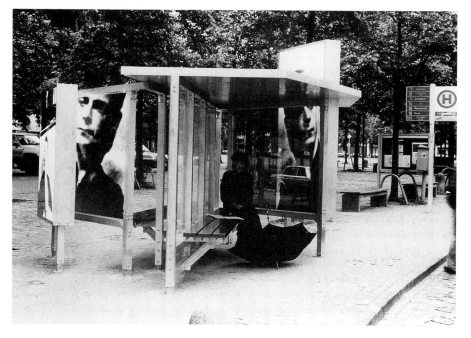

Dennis Adams, *Bus Shelter IV*

Adams redesigned them, replacing the standard "man work-ing" logo with photographs of various members of the city's immigrant population – a community whose shadowy exis-tence supports the city's prosperity.

Like Jaar, Adams refuses to provide viewers with a "correct" position toward the troubling issues he raises. The effectiveness of his projects as genuinely public works is connected to the way in which they insinuate themselves within, rather than imposing themselves upon, public spaces in the manner of the traditional public monument.

Krzysztof Wodiczko goes a step further, taking as his target the social and political consensus implied by the "official" archi-

tecture of corporate and public buildings and monuments. Projecting photographic images of objects and body fragments, he seeks to disrupt the reading implied by the heroic façades of these structures. In Trafalgar Square in London, for instance, he laid the image of a tank over the noble lion at the base of Nelson's Column, dramatizing the dissonance between the rhetoric and reality of war. At the New Museum in SoHo, New York City, he projected a set of padlocks and chains across the upper portions of the building, thereby acknowledging the fact that the floors lay empty due to the collapse of a scheme to develop them as luxury housing in the heart of a city where the homeless population has reached the tens of thousands. Just prior to the 1984 presidential election, he placed an image of a hand, cropped from a photograph of Ronald Reagan performing the pledge of allegiance, over the AT&T Building in New York, suggesting a link between corporate and political order.

Wodiczko's projections are temporary and (except in the case of a swastika surreptitiously projected on the façade of the South African embassy in London while working on his Nelson's Column piece) installed with the approval of the participating institutions. His success in acquiring approval for his projects may be related to the ambiguity of his messages. He subverts the usual codes governing public architecture, inserting reminders of the suppressed realities that underlie the façade of unity, but like Jaar and Adams he refuses the comfort of tidy answers, leaving the final interpretation to the viewers.

Such intentional ambiguity is also the mark of Jenny Holzer's work. Employing a variety of formats, Holzer has borrowed the technology and visual language of electronic advertising signage to convey messages that undermine assumptions about gender, authority, and power. Typically her signs are pro-

grammed to express a clash of voices that seem to emanate alternately from the advantaged and the dispossessed, the complacent and the outraged, the guarded and the hysterical. Recently the language has become increasingly complex and the flow of statements more obviously linked. In the gallery the signboards sometimes risk becoming absorbed by the postmodern machine, but when they have been installed in public places – for instance, the baggage area of the Las Vegas Airport or the scoreboard at Candlestick Park in San Francisco – they retain their ability to shock.

In many ways, the new social sculpture is an outgrowth of the concerns of conceptual artists like Joseph Kosuth and Lawrence Weiner, whose work during the seventies foregrounded and problematized the art object's institutional context and examined the means by which such objects came to acquire meaning. However, whereas more orthodox conceptualists have tended to restrict their investigations to the language of the art world, Jaar et al. have pushed this approach outward to encompass a much broader social agenda that includes issues of political power, gender, colonialism, and homelessness. As a result, their work has occasionally come under attack for failing to be "art." It is rather, the argument goes, a species of sociology, politics, or anthropology.

This argument reflects the still entrenched influence of the Greenbergian redefinition of modernism, which relegated art to an asocial, autonomous realm. In fact, however, such "social sculpture," far from being a strange and unaccountable mutant, is heir to the more neglected political modernism of the Russian avant-garde and Bertolt Brecht. Brecht's notion of "epic theater," with its reliance on the defamiliarization of the viewer through such devices as montage, disruption of narra-

tive, and intermingling of modes of high and popular culture, serves in many ways as a model for the interruptive strategy of the "social sculptors," as his emphasis on the role of the audience as producer of the work coincides with their hopes for the reactivation of a real public within that often moribund category known as public art. If there is something about their work that doesn't quite fit with the conventional image of public sculpture, we might remember Brecht's admonition: "Reality changes; in order to represent it, modes of representation must change."

What's Missing at
Battery Park?

Battery Park City rises pristinely from a landfill on the south-western tip of Manhattan. From a distance it shimmers like a magical Emerald City set apart from the confusion of the rest of New York City both by the aesthetic coherence of its granite and glass architecture and by a literal barrier of traffic formed by West Street that wraps around the complex like a protective moat crossable only by covered pedestrian bridges. Within the complex, all is clean, serene, and visually pleasing. Buildings housing office space, housing, and shopping areas are set among plazas, squares, and a riverfront esplanade that serve as settings for a series of public sculpture commissions.

For the latter, artists were brought in at an unusually early point in the project and in several cases actually collaborated with the architects. In the summer of 1989, three were unveiled to the public: an open colonnaded court by Ned Smyth, a futuristic gateway by R. M. Fischer, and a set of playful chair and table sculptures by Richard Artschwager. Earlier this year the most ambitious commission was completed at the south end of the project – a lyrical, landscaped park designed by artist Mary Miss

in collaboration with architect Stanton Eckstut and landscape architect Susan Child.

Both the complex as a whole and the individual art commissions have been lauded as examples of successful city planning. *New York Times* architecture critic Paul Goldberger, noting both the architectural coherence of Battery Park City's design and the deftly orchestrated coordination of public and private financing, remarked in 1986 that "The central idea of Battery Park City . . . is the concept of community." Reviewing the art proposals in 1983, *New York Times* art critic John Russell reported, "The general thrust of the plan was away from the hectoring monumentality of 'public sculpture' and toward a kind of art that gets down off the pedestal and works with everyday life as an equal partner." More recently, *New York* magazine critic Kay Larson, comparing the project's progress with the *Tilted Arc* debacle, argued, "There is a right way and a wrong way to insert art in public places, and Battery Park's fine arts committee has done everything right."

Yet, for all the praise of the planners' sensitivity to public needs and commitment to community, Battery Park City's concept is essentially extremely elitist. With its limited access, extremely high housing costs, and almost exclusively white clientele (the only nonwhite faces seem to belong to the service workers, who clearly live elsewhere), Battery Park City strikes one less as an oasis of urban calm and beauty than as an embattled fortress desperate to hold at bay the tidal wave of homelessness, crime, garbage, and chaos that threatens to overwhelm the rest of the city. The picture of an ideal city painted by supporters like Goldberger is at odds with the actual history of the project, which offers a cautionary tale of the decay

of belief in communal values, true diversity, and genuine urban life.

In a carefully researched article in the winter 1988 issue of *October,* Rosalyn Deutsche documented the evolution of the Battery Park City plan from the original conception in the late sixties of a multi-income development with a hefty proportion of subsidized housing into the current luxury compound. Whereas early rhetoric lauded (in the words of then Mayor John Lindsay) "the social benefits to be gained from having an economically integrated community in lower Manhattan," by 1979 New York's fiscal crises had forced a ceding of control of the project from public to private hands. In 1982 Richard Kahan, chief executive officer of the Battery Park City Authority, was able to argue, "We must establish Battery Park City as a high-quality, high-rent neighborhood. This encourages others to build, even at high cost, enabling the authority to generate the revenue it needs in the eighties to meet its responsibilities to bondholders." Currently the rental for a one-bedroom apartment in Battery Park City starts at over $2,000 a month.

Given these facts, how are we to evaluate the art commissions at Battery Park City? Is the site's economic history and social context irrelevant to a discussion of the art's success or failure? How truly "public" is art that ultimately advances an exclusionary view of community? Can one separate an artwork's aesthetic value from the ends to which it is put?

On purely aesthetic grounds, the commissions meet with varying degrees of success. Ned Smyth's *The Upper Room* is a mosaic-covered, postmodern fantasy that combines references to Roman and Gothic arches, Moorish ornament, and Egyptian columns. It sits in the middle of an open square like a theatrical stage set,

Ned Smyth, *The Upper Room*

inviting passersby to linger between the columns, sit at the central table inset with chess boards, and mingle in the manner of the inhabitants of the old-fashioned European city square. In reality, however, Smyth's court seems curiously underused. There is, despite its playful design and inviting spaces, something melan-

194

choly about the way it stands nearly or completely empty of inhabitants, like the symbol of a kind of community that no longer exists.

A similar sense of anachronism pervades R. M. Fischer's *Rector Gate*. Conceived in the artist's characteristic style of antiquated futurism, it is a 45-foot-high arch ornamented with cones, globes, and hovering rings. It makes a visual frame for the esplanade and river from one side and the congested skyline of Manhattan on the other. For all its whimsy, *Rector Gate,* like Smyth's court, seems somehow out of place. Both pieces refer to rituals and forms of social life that have little meaning in the modern world. Instead, like once functional structures transplanted into an alien world, their real purpose seems to exist only as a vague cultural memory.

Richard Artschwager's *Sitting/Stance,* a scattering of chairs and tables of granite, wood, and stainless steel, is more in keeping with current notions of what is to be expected in a public plaza. In fact, with their allusions to ship decks, thrones, tombstones, awnings, and deck furniture, the tables and chairs seem designed as self-conscious parodies of the sort of functional public sculptures we have come to expect from much exposed public artists like Scott Burton and Siah Armajani (who in fact were involved in the design of the complex's most important open plaza). Artschwager's contributions are clever, but not really inviting to casual passersby and seem to exist almost as a private joke for the cognoscenti.

These three commissions clearly go beyond the "turd in the plaza" school of public art and display an interest in exploring the meaning of public space. However, despite their reliance on forms and structures – courts, arches, benches, and tables – traditionally meant to bring urban strangers together, they fail

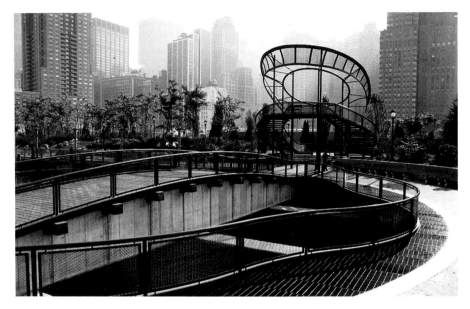

Mary Miss, *South Cove*

to transform the spaces they inhabit into truly public places. Mary Miss's *South Cove,* by contrast, is a remarkable marriage of art, architecture, and landscape that seems to accomplish this task. With its landscaped walkways, lookouts, pier, and vistas, it brings to mind the picturesque visions of Central Park's designer, Frederick Law Olmstead. Scattered boulders and lush plantings bring to mind Japanese gardens, while the battered wood pilings along the pier recall New York's history as a port town. Miss and her collaborators have created a total environment that seems much used, even by visitors who have no idea that they are wandering over a piece of public art.

Of all the commissions thus far completed (a Jennifer Bartlett collaboration is yet to be erected), *South Cove* comes closest to the notion of art that is public in more than name. At the same

time, however, even it can't completely escape collusion with the escapist orientation of Battery Park City. A fantasy of nature tamed and chaos restrained, it contributes to the sense of Battery Park City as a playground for the privileged.

Ultimately, the most troubling aspect of Battery Park City and the art commissions that ornament it is the evidence they provide that we have lost our sense of the larger meaning of the word "public." Public art has come to mean any artwork set in an open location, whereas public space is little more than that void through which passersby travel on their way from here to there. The notion that public art or public space might embody some shared communal value or experience has been all but lost. We forget that public art once consisted of commemorative monuments or structures that memorialized some culturally significant person or event. With the loss of any kind of consensus about what we as a people stand for (outside of the pursuit of self-interest at all costs), we are content to think of public spaces as those often blank and unloved plazas, squares, and so-called public amenities demanded of developers by New York City zoning codes.

It is possible for public art to have public meaning. This is clear from the example of Maya Lin's Vietnam Memorial in Washington, D.C. This remarkable work manages to embody the contradictory responses evoked by the war in Vietnam while bringing together veterans, survivors, and dissenters in a shared catharsis of national grief.

At Battery Park City, by contrast, we have a "public space" and "public art" that offer only the fantasy of cohesion and community. The unwelcome fact that haunts this complex is the realization that this fantasy can only exist through the relegation of a large chunk of reality to the other side of its protective wall.

Report from Newcastle

CULTIVATING AN ENGAGED
PUBLIC ART

> [A New Necessity] sets out to challenge the usual definition of an "art exhibition" by placing it fairly and squarely in the public eye. Its aim is to establish a role for art firmly within society rather than on its edges.
>
> Unsigned exhibition brochure

Following in the path pioneered by such exhibitions as the 1987 *Skulptur Projekte* in Münster and the 1986 *Chambres d'Amis* in Ghent, the 1990 summer's *A New Necessity,* organized by Declan McGonagle in the twin English cities of Gateshead and Newcastle, set out to redefine public art for the postmodern era. Seasoning the idealism of the modern era's faith in the transformative power of art with a realism rooted in the disillusioning cynicism of the eighties, the work in such shows represents an effort to insert art into the public realm in a way that genuinely engages issues of social context, local politics, and audience participation. Using a variety of strategies, which range from the adoption of a visual vernacular borrowed from advertising, urban architecture, billboards and street furniture, and collaboration with local community groups to subtle subversion of local rituals and monuments designed to reinforce illusions of social cohesion, this socially oriented public art is aimed at a revitalization of what seem, in the postindustrial societies of the late twentieth century, nearly vanished modes of public interaction

and behavior. A tall order in the best of circumstances, such an approach is easily sabotaged by a misreading of the receptivity of the audience or a mismatch between message and place. In the end, the laudable intentions behind *A New Necessity* were undermined by the rather bizarre context in which it was set.

The exhibition setting offered ample material for social comment and aesthetic intervention. Billed as "the First Tyne International," *A New Necessity* is conceived as the first of a series of international exhibitions that will bring art world attention to the north of England. Once dominated by a thriving ship-building industry, this region is now in the throes of recession as it struggles to replace its lost industrial base with a service-oriented economy. Thus, the twin cities of Newcastle and Gateshead (separated by the River Tyne) offer laboratories for the study of such Thatcher-era phenomena as deindustrialization, rising unemployment, economic polarization, and social homogenization.

In what must have seemed to the exhibition organizers a fortuitous coincidence, the area was slated for a Garden Festival, the Thatcher government's answer to economic stagnation. To American eyes, the Garden Festival is a peculiar combination of church social, county fair, and poor man's Disneyland, intended to provide troubled communities with an influx of ready cash by transforming them temporarily into tourist meccas. In response to criticism that the economic benefits of Garden Festivals are as transitory as the chicken-shaped topiaries, miniature Eiffel Towers, Third World villages, and caterpillar monorails to which they give birth, this particular Festival also featured exhibition spaces designed to be completed as low-income housing after the Festival closes.

A cluster of such buildings served as the core exhibition area for *A New Necessity,* while a small group of works were in-

stalled in scattered galleries in the Laing Art Gallery in Gateshead. The rest of the works were spread out, Münster-like, in artist-selected sites throughout the two cities. In all, *A New Necessity* featured the works of 44 artists of both international and local reputation. Although some submitted preexisting work, many created new projects for the show, much of it dealing with social issues ranging from the economic consequences of Thatcherism in Northern England, to the erasure of boundaries between public and private space, to questions of gender construction and class identity.

Much of the work installed in and around the housing shells took up issues related to home, community, social conditioning, and domesticity. Artists were free to transform the interiors into environmental works, and many of them chose to play with the future use of the space, deconstructing the concept of home and exploring the tension between public concerns and private space. Muntadas constructed an open house frame and electric fireplace within the two-story space, and projected a slide show of images borrowed from real estate and home magazines that graphically illustrated the way the mythology of Hearth and Home is used to sell goods. Dennis Adams suggested seepage of public concerns into private space by creating foyers to one of the building shells out of bus shelters adorned with images of bleak public housing projects in North-east England. Lee Jaffe's contribution, which involved the reconstruction of a Jamaican shack around an allegorical black figure impaled by spears equipped with tiny video monitors playing D. W. Griffith's notoriously racist *Birth of a Nation,* raised questions about race, slavery, and the relationship between freedom and economic power.

These darker visions of domesticity were countered by more

Muntadas, *Home, Where Is Home?*

upbeat demonstrations of the rejuvenation of community through craft. Newcastle-based artist Keith Alexander presented *A Room for Gateshead* filled with hand-crafted and decorated furnishings created in collaboration with a variety of community groups, including school children and people with mental handicaps, while Gateshead artist Christine Constant worked with women from several community centers to create ceramic tile murals inspired by the activities and conflicts of their daily lives. Infused with a sunny arts and crafts idealism, these projects were more interesting for their process than their products.

Other artists used these soon to be domestic spaces as if they were somewhat more traditional gallery spaces. London artist Rose Finn-Kelcey produced a theatrically eerie environment,

placing a set of faux doors along the fault line of the missing second floor, while New Zealand-born Bill Culbert filled the upper portion of a two-story space with a sunburst of fluorescent light bulbs. One of the most intriguing installations was by a transsexual artist named Liz Rowe. She presented a series of meticulously detailed, self-consciously "feminine" portraits and domestic genre paintings and drawings full of scrambled gender messages.

In the context of future public housing, previously exhibited works like the *Children's Pavilion* by Dan Graham and Jeff Wall and Krysztof Wodiczko's homeless vehicle took on new resonance, suggesting models of shelter based on utopian and dystopian visions of the future. However, perhaps the most pointed works in this section of the exhibition took on the Garden Festival itself. Gateshead area artist Dick Ward created a pair of playful cube figures that just bordered on kitsch, mimicking the gazebo-style architectural design of the Festival at large while gently mocking the gaping tourists come to pay it homage. Another Northeasterner, Chris Wainright, was more acerbic, contributing a large billboard with images of the Amazon Basin in an effort to contrast the threatened nature of the Amazon with its idealized counterpart in the Garden Festival.

The installations placed throughout the cities outside the Festival confines tended to deal more broadly with the urban context. Among the most notable of these projects were Thomas Lawson's sectional paintings placed above the Garden Festival site and over a soap works visible from either side of the Tyne. Noting that Newcastle's old city center, a square containing a statue of Saint George and the dragon, had all but disappeared beneath the encroachment of a glitzy new shopping mall, he memorialized the lost square and the form of social cohesion it

Thomas Lawson, *Memory Lingers Here*

embodied with simple silhouette images of the valiant Saint George. Paul Bradley, from Halifax, contributed two site-specific works. One, a pair of large metallic letters spelling out the words "True North" on the side of an abandoned warehouse, visible in the right light from the south side of the river, made poignant reference to the disappearing identity of Northern England as it loses its traditional industrial base and falls prey to the homogenizing tendencies of the sort of mass consumerism noted in Lawson's piece. Bradley's other work was more elusive, both literally and conceptually. Tucked into the arched doorway of a long-abandoned department store, Bradley's installation was composed of several thousand fencing posts stacked neatly, pointed edge outward, like the bristly seed pod of an industrial

growth that has long lain dormant. Meanwhile, what would undoubtedly have been one of the most effective works in the show was exhibited only in proposal form, pending more funds and the presentation of a second Tyne International. Tadashi Kawamata proposed to install a line of enormous construction cranes along a path bridging the two cities across the Tyne, tying the sites together and offering an optimistic tribute to the development possibilities of Northern England.

The third exhibition site, the Laing Art Gallery, seemed almost an afterthought, installed with not particularly relevant works by Nancy Spero, Tim Rollins, and Genevieve Cadieux, among others. The most interesting piece here (aside from the models and drawings of Kawamata's proposal) was a circular panorama painting of rushing water by Pat Steir.

In the end, despite a number of provocative works, the exhibition fell short of its lofty aims. It was hard not to suppress the cynical thought, observing the now standard mix of international circuit artists and local talent, that international shows such as these have become rather formulaic exercises in just the sort of local boosterism for which the much maligned Garden Festival was roundly criticized.

Why was the show less than the sum of its parts? Partly the problem was funding cuts, which made realization of some of the more interesting projects untenable. Partly it was a matter of fuzzy focus; the projects scattered throughout the city were too disparate and isolated to achieve the cumulative effect of a city transformed à la Münster, while the serious concerns of the projects centered within the Garden Festival site itself were trivialized by the surrounding carnival air. Meanwhile, the works in the Laing Gallery suggested a business-as-usual group show.

But beyond these specific problems, the exhibition highlights

the difficulties inherent in any attempt to collapse art into life. What of the non–art world public to whom this exhibition is ostensibly addressed? What do Garden Festival visitors who wander innocently into the Tyne International pavilion, stuffed with a surfeit of visual confectionery, make of these serious and elliptical works? Will they really be arrested and transformed or will they wander back out looking for something more immediately engaging?

The problem is, of course, that art that attempts to locate itself in the center of the political and social fray must of necessity be a peculiar hybrid. It must resist simplistic polemic while remaining accessible on some level. At its best, it may effect subtle interventions in the spaces of public life, bringing forward hidden contradictions, unacknowledged inequities, forgotten or overlooked social or historical aspects of the locality in which it is placed. However, work imbued with such multilayered complexities, hesitations, and deliberate ambiguities can never successfully compete in popular appeal with the supreme self-confidence of kitsch. Meanwhile, bending too far in the other direction entails the danger of a surrender to mass culture, which eliminates the possibility of critical distance.

In his catalog introduction, McGonagle maintains, "The possibility of art having a place in the social environment is not new, but I am not advocating some sort of return to the Middle Ages when art was part of the common currency. However, that principle is important because it depends on defining people as participants in a cultural process *already* rather than being simply consumers of cultural products." Despite the genuine efforts of all concerned, *A New Necessity* demonstrates yet again that however porous it may occasionally be rendered, the border between art and life remains firmly in place.

The Dematerialization of
Public Art

When Richard Serra's *Tilted Arc* was removed from Federal Plaza in downtown Manhattan on March 15, 1989, many tons of corten steel were not the only debris carted away from the site. Also tossed into the dustbin were a whole battery of assumptions about public art – who makes it, why it gets made, who it is for. Post *Tilted Arc,* the discussion has shifted away from the notion of site specificity as a response to the physical and formal dynamics of the site toward a concern with community as context.

Before the construction of *Tilted Arc,* Serra announced that "After the piece is built, the space will be understood primarily as a function of the sculpture."[1] Today, more often than not, the reverse seems to be true. Sculpture is seen as a function of the space or the context. Public artists tend to speak in terms of community participation, temporariness, or the limitation of the authorial role of the artist. Kate Ericson and Mel Ziegler, who have been very active in the public art arena of late, note that "art has the ability to be a valuable social tool" and describe their work as art intended "to be pragmatic, to deal with preex-

1. Quoted in Robert Storr, " 'Tilted Arc': Enemy of the People," *Art in America,* September 1985, p. 92.

isting social systems, and to carry on a dialogue with the public."[2] Of course, such concepts have been part of certain artists' thinking and practice for years. Now, however, they have come out into the open, becoming the stock in trade as well for art administrators, curators, and critics.

Is there something contradictory about the institutionalization of the participatory impulse in public art? Is it realistic to assume that consensus and community will always be progressive forces? If the artist becomes simply a conduit for other voices, is he or she still an artist? Has the reaction against *Tilted Arc* gone too far?

These questions are inspired by a two-day conference I attended in Chicago in December 1992. Sponsored by Sculpture Chicago, it brought together over 100 artists, critics, curators, and administrators to discuss issues raised by *Culture in Action,* the upcoming Sculpture Chicago program ("exhibition" doesn't seem to be quite the appropriate word here). Organized by Mary Jane Jacob, *Culture in Action* is probably the most ambitious effort to come to terms with the participatory impulse in recent public art to date. Eight artists or artist groups have been commissioned to create projects that bridge the gap between art and specific local communities. The artists, Mark Dion, Kate Ericson and Mel Ziegler, Simon Grennan and Christopher Sperandio, Haha, Suzanne Lacy, Daniel Martinez and Vinzula Kara, Inigo Manglano-Ovalle and Robert Peters, were chosen for their prior interest in this approach and were encouraged to reach out to locales that represented their particular areas of interest.

Proposals presented at the conference indicate that many of

2. Bradford R. Collins, "Report from Charleston: History Lessons," *Art in America,* November 1991, p. 71.

the artists have gone a long way toward the dematerialization of public art. It is hard to imagine what sort of exhibition or presentation will be possible when the projects are officially unveiled this summer [1993]. Simon Grennan and Christopher Sperandio are participating with the union of a Nestles's chocolate factory to create a worker-designed candy bar. Kate Ericson and Mel Ziegler will design a paint chart in cooperation with the residents of a local housing project. The Chicago-based artists' collective Haha will plant a hydroponic garden whose harvest will be supplied to an AIDS hospice. Suzanne Lacy will cap a series of community-based performances dealing with the history of immigrant women with a dinner for a group of important women leaders. Mark Dion will work with a group of African American high school students to create an installation for a museum of ecology in Belize.

Hanging over the conference, despite various attempts to dismiss it as a nonissue, was the question: What makes such projects art and not social work or community activism? In the discussion group I attended, the answers seemed somewhat unsatisfying, ranging from assertions that this is art because an artist made it and the art community accepts it as such to the argument that these projects are art because they operate in the metaphoric as well as the practical realm. Despite the gnawing sense that the question is a red herring (it has, after all, tended to be the most common ground for recent Right Wing attacks on contemporary art), it simply refused to go away. Instead, conference participants, generally representatives of the more progressive wing of the art world, were forced to deal with the often unexpected consequences of their own assumptions.

In retrospect, I think the difficulties that surfaced during the conference arise at least in part because it is impossible to dis-

Haha, *Flood: A Volunteer Network for Active Participation in Healthcare*

cuss work like this in isolation from its history. There is indeed something paradoxical about the creation of art for which there is no product, artist, or even audience in any conventional sense of the term. To be judged fairly, *Culture in Action* must be seen not as an excursion into a quirky form of postconceptualism, but as the latest volley in an argument about the nature of art and the nature of public space that has been going on for some time. Historical precedents include Russian constructivism, with its confidence in art's ability to transform the face and the spirit of modern life; situationism, which preached the transformation of the city through a revolutionary merger of art practice and social behavior; and fluxus and conceptualism, both devoted to the collapse of art into life. Meanwhile, from another corner, historians and urban sociologists have been engaged in discussions of the meaning and political uses of public space, the impoverishment of public life, and the possibilities for its rehabilitation and revitalization through art, architecture, and a more creative kind of city planning. Also relevant are models for collaborative art-making as they have been explored by community-based artists like Judy Baca and her mural projects; Mierle Ukeles, for 25 years the unsalaried, official artist in residence at the New York Department of Sanitation; and Tim Rollins and his Bronx-based Kids of Survival.

As an exhibition, *Culture in Action* can be seen as the latest in a series of large-scale public projects that have begun to redefine the direction of public art. A brief history suggests the trajectory of the impulse. The first and perhaps still most influential "contextual" public art exhibition was the 1987 *Skulptur Projekte* organized by Kasper Konig and Klaus Bussmann in the city of Münster, West Germany. Fifty-four artists from around the

world were invited to create site-specific public works in a city whose history presented rich aesthetic and social possibilities.

Bombed heavily at the end of World War II, many parts of Münster were restored during the fifties to their prewar condition, while others were rebuilt in the faceless fifties-style modernism that was the order of the day. Artists chose to deal with the city from many perspectives. Some focused on specific historical events, making reference in their work to the barbarities of the city's medieval and Nazi past, for instance; others embellished Münster's green spaces with garden or park structures; and still others slyly pointed up the inhumane atmosphere that characterizes much of the postwar reconstruction of the city. Together the works in the exhibition offered a mosaic of meditations on German history, the industrialized city, and the spiritual impoverishment of modern life.

A high-visibility project, *Skulptur Projekte* became a model for this increasingly popular approach to public art. In the summer of 1990 *A New Necessity,* organized by Declan McGonagle, opened in the twin English cities of Newcastle and Gateshead. Designed to draw attention to the economic and social difficulties of Northern England at the end of the Thatcher era, the exhibition was inserted into a larger Garden Festival, which offered artists the opportunity to play their own darker visions off the chamber of commerce optimism of the government-sponsored festival. Although artists were invited to place work anywhere in the two cities, some of the most pointed were placed within the shells of public housing projects that were to be completed and occupied after the closing of the festival. Artists like Muntadas, Dennis Adams, and Lee Jaffe took advantage of this context to examine politi-

cal and social contradictions in conventional distinctions between public and private.

Similarly situated in an apparently antagonistic context was last year's *Allocations,* organized by Maria Rosa Boezem and Jouke Kleerbezem. This was part of the *Floriade,* an international horticultural fair installed in the new town of Zoetermeer, just outside the Hauge in Holland. The 23 artists were asked to deal with the specific context of the show by focusing on themes like the commercialization of public space and the clash between nature and culture. Again, the most effective installations (in particular works by Mel Chin and Mierle Ukeles) were intended to counter the prevailing spirit of technological celebration.

But for our purposes, the most important of Münster's progeny was *Places with a Past,* an exhibition organized by Mary Jane Jacob for the 1991 Spoleto Festival in Charleston, South Carolina. But while *Skulptur Projekte* took a very broad approach to the notion of city as an art context, *Places with a Past* was more focused in its use of art to address the city's, and the region's, social and political history. Asked to function as "artist archeologist," the nineteen artists in the exhibition created installations within such disparate locations as the city's Old Jail, the slave quarters of the Governor's Mansion, a Baptist church, an old automotive garage, various historic and abandoned houses, the local art museum, and an African American study center. The majority of the artists, who were all outsiders to the community, chose to focus on such obvious historical configurations as the Civil War and the southern slave trade.

Although *Places with a Past* was well received on aesthetic terms, commentators also pointed out a gap between its rhetoric of social engagement and its rather cavalier attitude toward the local population. Only one of the projects, a funky two-

story neighborhood center erected by David Hammons in collaboration with a local artist and building contractor, reached out to the local community in any meaningful way. The other works, many of them rich and powerful in their own way, were essentially addressed to the art cognoscenti who made the pilgrimage to Charleston. They employed a visual and conceptual language that did not travel well outside the art ghetto, and the issues they chose to address often had more to do with the artist's personal explorations than with concerns that might be easily recognized by Charleston's ordinary citizens.

In Public, organized by the Seattle Arts Commission in 1991, was specifically designed to address the gap between art and the nonart public, which has invariably haunted large scale-public art exhibitions like those discussed earlier. For this exhibition, artists were invited to intervene in the ongoing processes of daily life in Seattle. A local historian was made available to the artists, a third of whom were from the Seattle area, and artists were encouraged to explore a variety of community interactions. Many of the most interesting projects came from local artists, who were less restricted by the limited budget and more familiar with local issues. One team, Gloria Bornstein and Donald Fels, provided an alternative to the official history of the waterfront with signs and a telephone voice line set alongside long-standing historical markers. Another artist, Robert Herdlein, volunteered as an art teacher for a local community center and arranged an exhibition of his students' work. Other artists appropriated various existing public address systems – street banners, bus posters, local newspaper ads, and public television spots – to convey messages about AIDS, economic inequality, and the invisibility of the local Native American population.

The reception of *In Public* was mixed. Although there were

problems of finances and organization (many of the projects were not completed by the summer 1991 opening, and a number were never completed at all), the biggest problem seemed to stem from the art public's expectations about what the show was supposed to be. Whereas one could take a map and visit the various projects scattered throughout Charleston and Münster, in Seattle there was, in many cases, virtually nothing to see. Meanwhile, the art that was visible failed to conform to its audience's expectations about public art. This led to a major public controversy, fueled by a local merchant group and expanding to the local newspapers, television and radio, over a set of street banners by Daniel Martinez that outlined the disparity between America's haves and have-nots with a series of starkly phrased questions. Although it seems clear that the content of the banners was the real point of contention, the debate inevitably devolved into a discussion of "Is it art?" and "How much taxpayer money went into this junk?"

In Public's emphasis on process over product became an almost exclusive focus in *Culture in Action*. At the conference, participating artists scornfully dismissed the imposition of artistic intentions as "imperialistic" and aesthetic considerations as beholden to outmoded "high culture values." They spoke frequently of their desire to act as catalysts, to give the members of the marginalized community with which they were working a voice of their own.

As one who has been very sympathetic to the reinvention of public art along more participatory and democratic lines, I found myself torn. On the one hand, I do believe that a self-conscious or critical public art can play a role in the reactivation of public space and life. By pointing to the social and political contradictions of contemporary American society, I think that

Daniel Martinez, *Nine Ways to Improve the Quality of Your Life*

artists like Hans Haacke, Dennis Adams, Krzysztof Wodizcko, and others have suggested ways that art can be employed to inspire private thought and public debate over pressing social issues. Meanwhile, another approach to genuinely public art is suggested by the work of "eco-artists" like Mierle Ukeles, Helen and Newton Harrison, and Mel Chin, who have joined forces with technical specialists in other fields to explore new ways of thinking about solutions to apparently intractable environmental problems.

On the other hand, *Culture in Action* raises questions that I find very difficult to answer. Is it a mistake to dismiss the conventions of high art so completely? Might there be something productive about the tension between art language and public expectations? I think, for example, of Maya Lin's Vietnam Memorial. By relying on a minimalist aesthetic, Lin was able to avoid the specificity and heightened emotionalism that might have made her monument as divisive as the war it commemorates. Instead, the stark simplicity of her wall of stone permits viewers from many different backgrounds to approach the monument on their own terms, and thus finally to acknowledge and accept the contradictory nature of our national experience in Vietnam.

Can one go too far in the direction of consensus and community? Here I think of the recent controversy over John Ahearn's *Bronx Sculpture Park*. In the wake of community objections that the figural sculptures Ahearn created from casts of neighborhood residents provided a poor representation of the community, this work was removed just a few days àfter it was installed. Ahearn's willingness to listen to the community is commendable, but the removal of the work raises some distressing questions. If we reduce public art to the role of

promoting community self-esteem, have we come that far from the false consensus implied by the traditional war memorial, or public statue? Applied to the case of *Culture in Action,* I fear that the tendency to romanticize community may prevent some of the artists from acknowledging the real tensions and conflicts that underlie any group interaction.

Isn't there something disingenuous about the claim that these works are addressed to a general public rather than to the art world proper? In fact, artworks that are so ephemeral that their only trace is a handful of candy bars or a community dinner ultimately exist in any lasting way only through the intervention of the art media that document, memorialize and explain them. Artists may argue, as one of the participants did at the conference, that it is enough if one family is affected by a work of art, but in fact, the large sums of money represented by this effort are obviously aimed at greater numbers than that. So in fact, despite protestations of their independence, aren't projects like this inextricably complicit with the bad old art apparatus they decry?

And finally, do projects like *Culture in Action* run the risk of institutionalizing something that should happen in a more organic manner? Inviting artists into a community to perform a short-term collaboration smacks of another kind of paternalism that assumes that artists with a superficial understanding of a community's needs and history can supply the conceptual tools to solve its problems. Is this kind of work best left to local artists who know and understand the communities in which they work and who develop long-term relationships with other community members?

Having said all this, I feel torn again, this time by the ease with which one can undermine anything that is unorthodox and

experimental. Viewed in the larger context of ongoing attempts to reexamine the definition of public art and to explore new ways to draw art into life, *Culture in Action* is a bold effort to push certain assumptions to their logical extreme. Several times in the conference, speakers conjured up the image of the public realm as a kind of experimental laboratory. Public art is certainly one of the most active areas of artistic "research and development" these days. If *Culture in Action* and the participatory tendency it celebrates raise these many questions, might that alone be sufficient justification for its existence?

Name Index

Pages with illustrations are indicated by bold numbers.